MUNCH

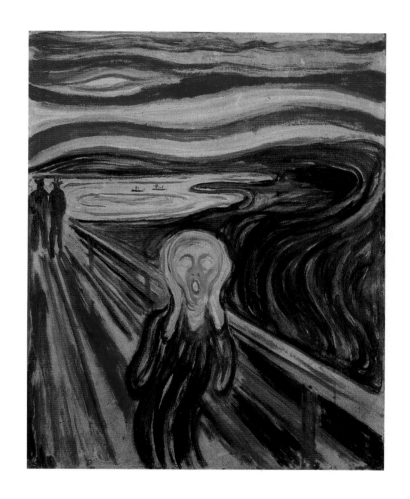

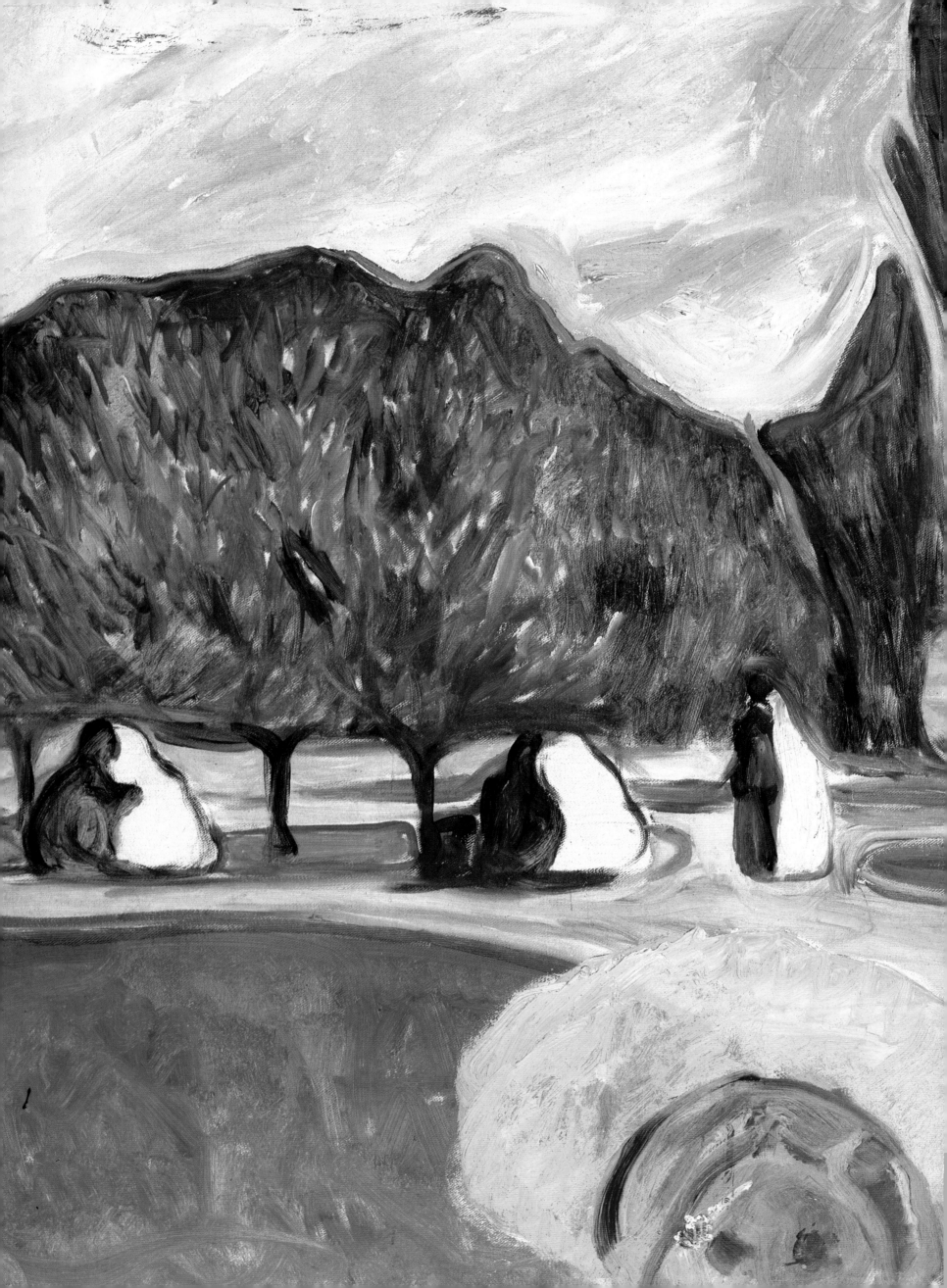

MUNCH

David Loshak

SMITHMARK

This edition published in 1994
by SMITHMARK Publishers Inc.,
16 East 32nd Street
New York, New York 10016

SMITHMARK books are available for bulk
purchase for sales promotion and premium use.
For details write or telephone the Manager of
Special Sales, SMITHMARK Publishers Inc.,
16 East 32nd Street, New York, NY 10016.
(212) 532-6600.

Produced by Brompton Books Corp.,
15 Sherwood Place
Greenwich, CT 06830

ISBN 0-8317-6118-0

Printed in China

10 9 8 7 6 5 4 3 2 1

In memory of Edith Pashby

I want to thank Rikke Schwartz for her
generous help in preparing the
manuscript, Aileen Reid for sterling
editorial co-operation, and my wife Inge
for many helpful discussions.

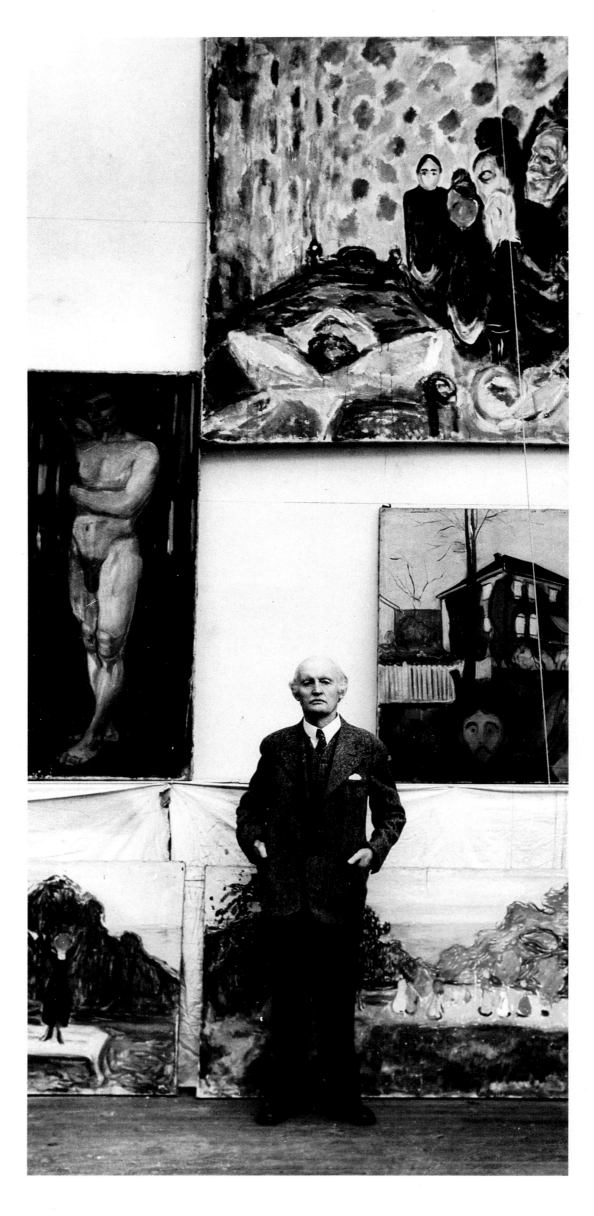

Page 1: *The Scream*, 1893

Page 2-3: *Loving Couples in the Park
(The Linde Frieze)*, 1904

Right: Munch in his studio at Ekely in
1938.

Contents and List of Plates

Introduction

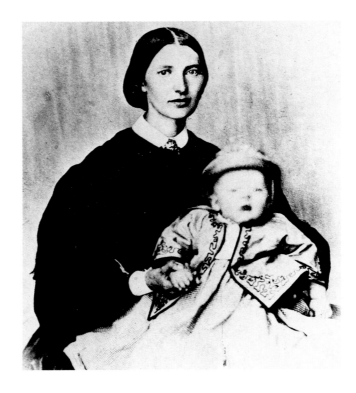

Left: Edvard Munch with his mother, 1864. Munch's mother was to die of tuberculosis when he was five years old.

More obviously than in the case of most artists, Edvard Munch's genius was molded by the circumstances of his life. He was born in 1863 at Løten, north of Christiania (now Oslo), the second of five children of Dr Christian Munch, an army physician, and his wife Laura Cathrine, née Bjølstad. Though of modest means, the family belonged to the intellectual bourgeoisie, and Edvard's uncle was the great Norwegian historian Peter Andreas Munch. While Munch was still an infant his family moved to Christiania where he grew up. At first they lived in an old part of the town, later moving to Grünerløkka, a new working-class suburb. When he was five years old his mother died of tuberculosis and the household management was taken over by her sister Karen Bjølstad. Edvard loved his Aunt Karen and remained devoted to her throughout her long life, but she never superseded his mother, whose loss he felt very keenly. Further tragedies ensued: his sister Sophie, a year older, to whom he had been close, also died of tuberculosis, when he was fourteen, and a younger sister, Laura, became mentally ill and at times had to be confined in an institution. Edvard's own health was delicate. His father, originally of a kindly and cheerful disposition, grew puritanically religious, suffering from spells of remorse and depression and subject to explosive rages bordering on insanity. Even without the confirmation supplied by Munch's own copious notes and diaries it would be clear that such a family background was conducive to anguish and must have exacerbated whatever innate neurotic tendencies he possessed. No wonder he painted death and disease so frequently, especially in his earlier career. Such themes were common in late nineteenth-century painting but in Munch's case, as he himself noted, they were founded on personal experience beyond that of most other artists.

While Munch was still a child his artistic talent was noticed by his Aunt Karen, who encouraged him to draw and later to paint. In 1879 he entered the Christiania Technical College in order to study engineering. By the following year, however, he had dropped this aim and decided to take up painting. For a short while he was enrolled at the School of Design, first studying freehand drawing and later modeling with the conservative sculptor Julius Middelthun. That his gifts, however, were essentially pictorial rather than sculptural is corroborated by the fact that despite this training he rarely produced any sculpture throughout a long and prolific career. In 1882, together with six other budding artists, he rented a studio where their work was supervised by Christian Krohg, in some ways the most radical, politically as well as artistically, of the new naturalistic painters in Norway. Another prominent naturalist, the landscape painter Frits Thaulow, held a class in painting in his open-air studio at Modum which Munch attended in the summer of 1883. Apart from very brief study with Léon Bonnat in Paris several years later, this completed his artistic education. Obviously to a substantial degree he was self-taught. This was in harmony with naturalistic thinking, according to which direct observation of nature should be the painter's chief guide. Krohg and Thaulow, together with a third outstanding naturalist, Erik Werenskiold, were chiefly instrumental in establishing annual Fall Exhibitions in competition with those of the old, conservative Art Association, and to these exhibitions were admitted works by fledgling painters often no more than half-trained, among them Munch. Some of his exhibits, including the famous *Sick Child* (page 24), were already provokingly innovative in style and content, and for the most part the press judged his work unfavorably. He had a hard time economically but he did achieve recognition from a small group of progressives.

Around 1884 Munch drifted into the circle of radical writers and artists known as the Christiania Bohemia, from the title of a banned novel by its leader, the anarchist thinker Hans Jaeger; Krohg was a prominent member of the group. These men, under the influence of, among others, Emile Zola and the Danish critic Georg Brandes, advocated naturalism in art and held advanced views on a wide range of political, social and moral issues, including social and economic justice, women's rights, and atheism or freethink-

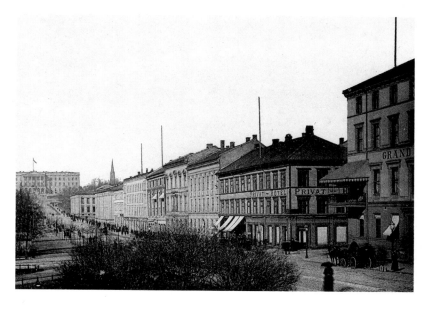

Above: Karl Johan Street, Oslo's main thoroughfare, c. 1887. Munch painted a similar view in 1891 (page 34).
Above right: Munch painting at Åsgårdstrand, 1889.

Above: Edvard Munch, 1885
Below: *The Dying Child* by Hans Heyerdahl, 1882.
Below right: *Spring* by Edvard Munch, 1889. This more conventional treatment of the theme of *The Sick Child* (page 24) proved highly popular at Munch's one-man show in 1889.

ing in religion. Though he retained his independence, their views made an enduring impression on Munch. They also preached and practiced free love, with not altogether fortunate results, as they failed to take into account the jealousies it aroused. Not much is known of Munch's affairs except the most important, his intermittent liaison with Millie (Ihlen) Thaulow, the wife of a naval physician related to both Munch and Frits Thaulow, who in the end jilted him. He was embittered by this experience; she was his femme fatale, the primary source of his subsequent misgivings about women.

Thanks to the generosity of Frits Thaulow, who was a friend of his father, the young Munch was able to take a three-week trip to Paris, via Antwerp, in 1885. Apart from visits to the Louvre and the Salon, what he saw there is not known, but presumably he encountered works by Manet (whose effect can be detected in his work of the following years), and possibly other modernists. A visit to Copenhagen in 1888, at a time when there was a big French exhibition, certainly acquainted him with some of the French Impressionists, including Jean-François Raffaëlli. In 1889 he spent the first of many summers at Åsgårdstrand, on the Oslo Fjord. He was immensely attracted to this seaside village, which he used as a

background in a number of pictures and where he eventually bought a cottage. That same year he took a daring step for a controversial young Christiania artist by holding a one-man show. The response was more favorable than might have been expected, probably in part because the exhibition centered on *Spring*, a big picture in a more than usually conservative style, which proved highly popular. As a result, on the recommendation of an influential critic he successfully applied for a state scholarship to enable him to study in Paris. There he went that fall, enrolling in the school of Léon Bonnat, a relatively conservative painter who was a popular teacher among foreign art students, including Scandinavians. Munch, however, was bored by his teaching and remained his pupil officially for only four months – probably, in fact, for no more than a few weeks. Soon after arriving he learnt of the death of his father, which besides affecting him deeply caused financial worries occasioned by the need to help his now impoverished family. But with the aid of a second scholarship he remained in France for over two years, living in Paris and nearby St Cloud, with brief stays in Nice and summer trips home to Christiania and Åsgårdstrand. During this time he often suffered from loneliness and ill-health.

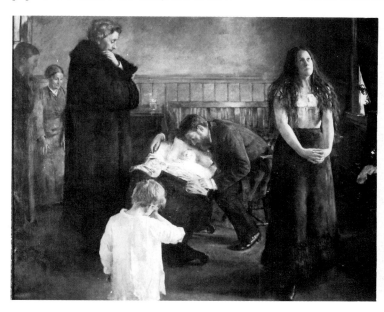

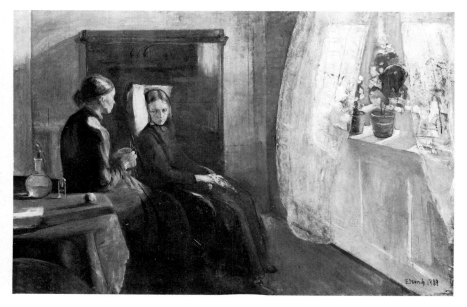

His only close friend appears to have been Emanuel Goldstein, the Danish symbolist poet. Artistically he was changing rapidly. He had ample opportunity to become familiar with the newer movements in French painting, including impressionism, neo-impressionism (or pointillism), and the symbolism or synthetism of Gauguin and his followers, shading into art nouveau. Though Munch never fully absorbed any of these developments they successively acted to transform his art. Meanwhile an idea began to take shape in his mind of grouping together as a series those of his subjects that dealt more fundamentally with the tragedies and problems of life, love and death. Many of these subjects were derived from notes he had written in Christiania years before; some he had already painted in early versions, some were in a state of gestation, others were to come in the future. Munch believed that combining related subjects into a unified scheme would increase the expressive impact of the individual pictures. Ultimately the notion crystalized into what he eventually called the Frieze of Life: the permanent decoration of a single hall by such pictures, hung to surround it in a continuous series. The idea was not new; G F Watts had a very similar one over forty years earlier, which he called the House of Life. However there is no evidence that Munch knew this. Neither Watts nor Munch ever realized their ideal. The Frieze of Life, though its components were later exhibited, was never much more than a loose theoretical framework to encompass the most serious subjects of the painter's earlier career.

After returning to Christiania for an exhibition in 1892, feeling himself alienated from artistic life in Norway Munch accepted an invitation to hold an exhibition at the Berlin Artists' Association and moved to that city. The exhibition itself was disastrous; it so shocked the public and the more conservative artists that it had to be closed after a week. But it gave Munch a profitable notoriety. He was taken up by art dealers who arranged exhibitions of his work in various German cities, from the admission charges of which he derived a small income that compensated a little for the meager sale of his pictures. He was nevertheless obliged to live in relative poverty. By a small but increasing number, however, his art was genuinely admired; they included Walther Rathenau, the idealistic director of the AEG company, who became one of his first German patrons.

In Berlin he mixed with a new set of bohemians, this time of more international composition. Key members included the Polish novelist Stanislaw Przybyszewski, the Swedish dramatist August

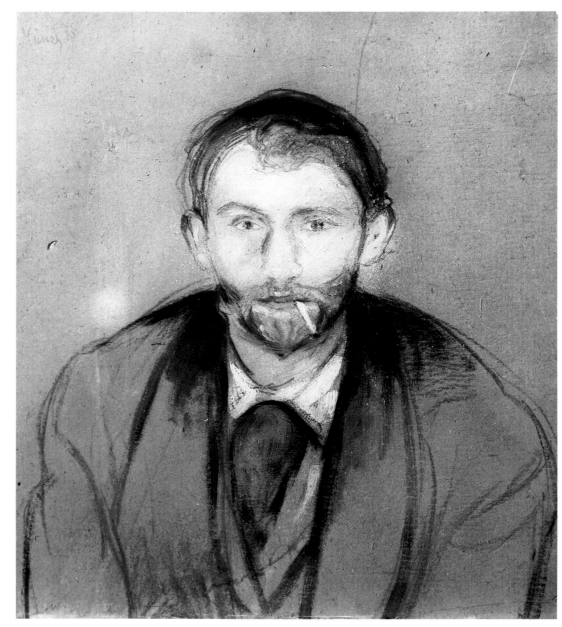

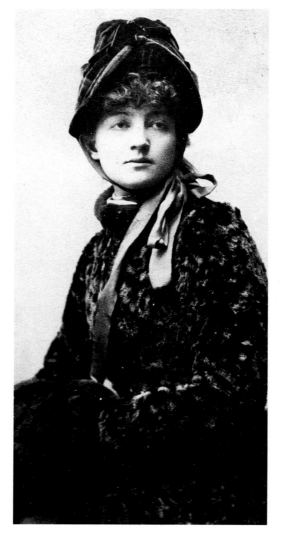

Above: *Stanislaw Przybyszewski* by Edvard Munch, 1893-5. This Polish novelist and playwright was a member of the set of bohemians with whom Munch associated in Berlin.
Left: Dagny Juel was Przybyzsewski's Norwegian wife. She was a believer in free love and the many who were in love with her included Strindberg and probably Munch, who painted her portrait in 1893 (page 45).
Above right: *The Maiden and the Heart*, color woodcut, 1899. Munch's repertoire of printmaking was greatly expanded by his collaboration with the Paris printer Auguste Clot.
Right: *Self-portrait with Skeleton Arm*, lithograph by Edvard Munch, 1895.

Strindberg and the German poet Richard Dehmel. They drank heavily and often met at the tavern called Zum Schwarzen Ferkel (At the Black Piglet). On the whole they were less concerned with social questions than the Christiania Bohemia and tended rather to dabble in mysticism, psychology, the pessimism and misogyny of Schopenhauer and Nietzscheian individualism. Sex, especially the sensual and supposedly demonic qualities of women, occupied a good deal of their attention. Again free love was practiced and again jealousies appeared, centering on Dagny Juel, Przybyszewski's seductive Norwegian wife, with whom several of the circle were apparently in love, including Strindberg and

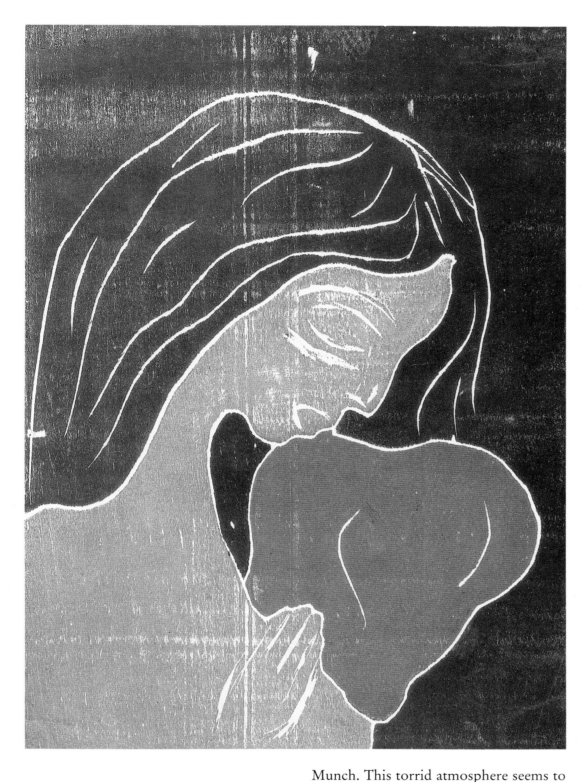

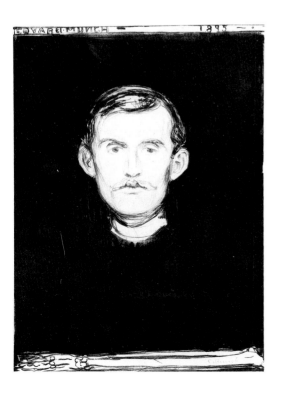

Germany besides visiting Copenhagen, Stockholm and Paris. Many years later, after his finances had greatly improved, he would buy or rent houses in rapid succession at different places in southern Norway, sometimes making only slight use of them.

At the end of 1895 Munch returned to Christiania where he held an exhibition that was roundly condemned except by a few. On the basis of this show some considered him insane. While there, however, he met Ibsen, who was encouraging. Early in 1896 he went to Paris, where he spent most of the next two years and where his art began to receive a measure of recognition; his exhibits at the Salon des Indépendents were noticed favorably by some critics both in France and abroad, including Norway. He made new friends, including the poet Stéphane Mallarmé and the composer Frederick Delius. It is one of the paradoxes of Munch's life that throughout much of it he seems to have been sociable and had dozens of friends, not to speak of many affairs with women, yet at the same time he was shy and retiring; loneliness is a persistent theme in his work. Much of his time in Paris was devoted to the manufacture of prints, which he produced in great quantity. He had already mastered etching, drypoint, aquatint and lithography. Now, working in collaboration with the Paris printer Auguste Clot, he greatly expanded his repertoire of techniques, turning out woodcuts, in colors as well as monochrome, colored lithographs, relief prints, mezzotints, and prints produced by various mixtures of media. While a great many of these prints reproduce the compositions of his paintings, they are always independent works of art in which small changes, simplifications, new linear idioms and differences of color (often several variations in different impressions of the same print) introduce new shades of emotional effect. Munch became a technical virtuoso of printmaking and is said never to have been happier than when engaged in this occupation. Braving the risks of indulging in amateur psychology, I shall offer the opinion that this activity helped him to preserve a degree of mental balance during his subsequent period alcoholism and personal trouble and probably postponed by years his eventual breakdown. As a painter, almost from the start he had tended to be sketchy and impulsive, too impatient with inessentials to go beyond the gist of an idea and undertake the careful, tedious work needed to 'finish' a picture. In some cases he would later rework it but leave it equally 'unfinished,' or make replicas or variations in which other aspects of the subject could be revealed. It was this slapdash execution as much as his unconventional subjects that offended critics and aroused doubts

Munch. This torrid atmosphere seems to have had a stimulating effect on Munch's artistic powers, for during his three years in Berlin he painted many of the masterpieces of his symbolist phase, among them the celebrated *Scream* (page 47). He also produced a number of etchings and drypoints, which marked the start of his important career as a printmaker. At the same time his mental stress may have increased. The most obvious symptom was the beginning of a restlessness that caused him to adopt an itinerant way of life which he pursued with few intermissions for the next fifteen years. Sometimes he traveled with his numerous exhibitions, sometimes simply wandered from place to place for no apparent reason other than the need for a change, setting up his easel in dingy lodgings in provincial towns, often returning to Norway for a summer at Åsgårdstrand. Even during the period 1892-95, when he was more or less settled in Berlin, he traveled to various towns in

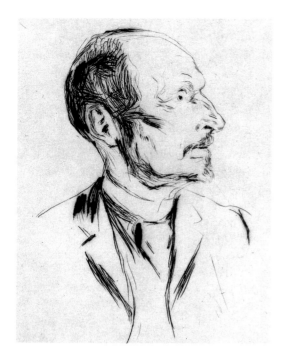

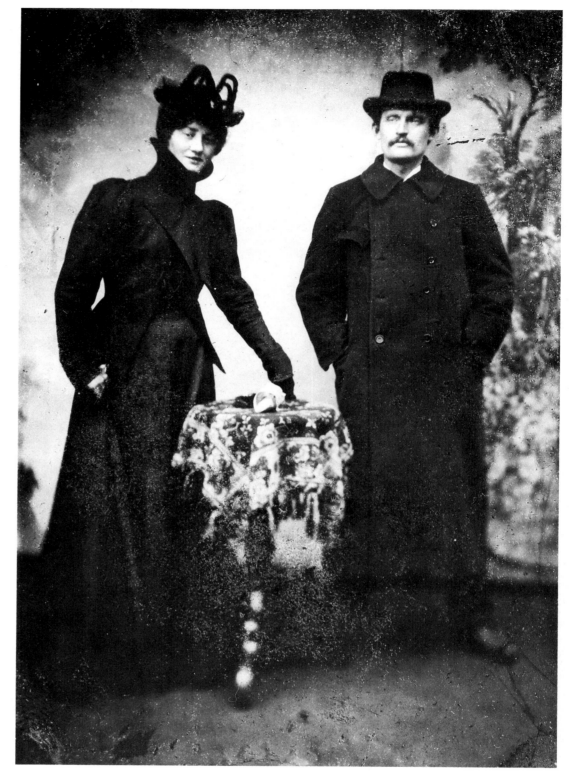

as to his sanity. Some types of prints could be sketched as freely as drawings or paintings, but others, notably woodcuts, demanded care, accuracy and patient labor. In producing them Munch willingly imposed upon himself a discipline absent in other departments of his life and work. Significantly, he made no woodcuts during the years immediately before his breakdown in 1908.

During the decade preceding that year, Munch's life progressed in two opposite directions: professionally he made a great advance, initially in fame and repute, ultimately also financially; privately he deteriorated in happiness and health. At first he lived chiefly in Christiania, later in Berlin and alsewhere in Germany, but essentially he remained 'of no fixed address'; the peripatetic existence continued. As obsessive as his travel was his 'exhibitionism'; between 1892 and 1909 he is said to have exhibited 108 times in group and one-man shows in various countries, above all Germany. Here his major breakthrough came at the Berlin Secession exhibition of 1902, where a fairly comprehensive version of the Frieze of Life was hung in a frieze-like sequence, the pictures divided into three iconographic groups dealing respectively with love, fear of life, and death. The show received much publicity and the critics were on the whole favorably impressed. Soon afterwards Munch became friendly with Albert Kollmann, a businessman, mystic and connoisseur who fostered the sale of his works and introduced him to one of his important patrons, the wealthy Lübeck oculist and collector of modern art, Dr Max Linde. The doctor wrote a brief book in praise of Munch, who stayed several times at his beautiful house, painted portraits of the Linde family and executed a frieze to decorate the children's nursery (pages 78-79). Other rich patrons followed, such as the Chemnitz stocking manufacturer Her-

bert Esche and the Swedish banker Ernest Thiel. For a time in 1904 Munch lived in Weimar where he was befriended by Count Harry Kessler, director of the art academy. Of all these people and many others he painted portraits, and for several years practiced portrait painting as a lucrative occupation. He concluded contracts with the Berlin dealer Bruno Cassirer for the exclusive sale of his prints in Germany and with the Commeter gallery in Hamburg for paintings, though finding these agreements too restrictive he had them annulled a few years later. Recognition also grew in Norway, if more slowly. The National Gallery in Christiania bought a few of his works, and Munch's friend Jens Thiis, an art historian, was a faithful advocate. A considerable number of his paintings, including some of the finest, were acquired over the years by the discerning Norwegian in-

dustrialist Olaf Schou.

Munch's private life was a different story. In 1898 he began a serious affair with Tulla Larsen, the beautiful and sophisticated daughter of a rich Norwegian wine merchant who herself had contacts with the Christiania Bohemia. Before long she importuned him to marry her. Greatly attracted, he was tempted to do so but ultimately refused, apparently for four reasons: firstly, he thought himself unsuited for marriage because he considered his heritage tainted by tuberculosis and madness (which he associated with his father as well as his sister Laura); secondly, in line with the misogyny of his Berlin friends he felt his individuality and artistic powers would be devoured by a wife and family; thirdly, he believed the financial arrangements stipulated by the wealthy Tulla would be humiliating to a still-poor artist; and fourthly, he was

Far left: This 1902 Munch drypoint depicts *Albert Kollmann*, a German businessman who championed Munch's work.

Left: Edvard Munch and Tulla Larsen, 1899 Munch's affair with Tulla Larsen nearly culminated in marriage but he decided against such a move for a variety of reasons including the belief that his family was tainted by disease.

Right: *The Brooch*, 1903. This lithograph shows the violinist Eva Mudocci with whom Munch had a an intermittent liaison.

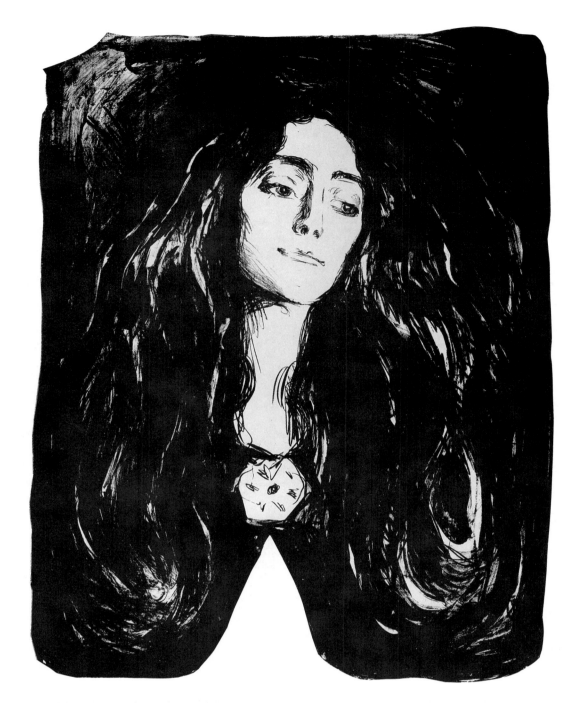

jealous of her former lovers. After they had traveled together on two trips to Italy and elsewhere, he left her. Meanwhile, beset by poor health and increasing addiction to alcohol, he spent time in a sanitorium in Gudbrandsdal, Norway. Although by 1900 the affair was apparently in abbeyance, Tulla did not give up, and at Åsgårdstrand in the summer of 1902 with the help of mutual friends she staged a tricky confrontation in the heat of which, a revolver having been produced, Munch accidentally shot off part of a finger of his left hand. The experience proved traumatic. His feeling for Tulla turned to hatred, he quarreled with their mutual friends and began to acquire a persecution complex. In Paris the following year a sporadic love affair began with the young English concert violinist Eva Mudocci which, though providing agreeable interludes for several years, failed to allay his basic mental stress. His behavior during drinking bouts became violent and he was involved in several well-publicized brawls. The most serious of these occurred at Åsgårdstrand in 1905 when he had a fight with the younger painter Ludvig Karsten. As a result of this he stayed away from Norway for a few years. In vain attempts to cure his alcoholism he visited several German spas. Needing a substitute for Åsgårdstrand outside Norway, he spent two summers at Warnemunde, a small seaside resort on the Baltic coast, and here he seems to have found some peace. But in Copenhagen in 1908 his troubles returned in acute form; he suffered from hallucinations and felt he was going mad. With help of his old friend Goldstein he entered the fashionable clinic of the Copenhagen psychiatrist Dr Daniel Jacobson, where he remained for eight months.

Throughout his stay he kept busy with his art, producing among other works the portrait of Dr Jacobson (page 86) and his own story *Alpha and Omega*, illustrated with lithographs. For whatever reason, whether it was the electricity and massage treatment we know he received, other therapy unknown, the kindness of the nurses, or Dr Jacobson's formidable personality, he emerged from the clinic cured. Never again did he drink to excess or suffer a mental collapse. His way of life, however, changed, as did the empha-

Above: *The Blue Kitchen*, 1913, by Ludvig Karsten. In 1905 Munch came close to murdering his friend Karsten during a fight, when he shot at him but missed.

sis of his artistic interests. From now on he lived almost entirely in southern Norway, with only occasional visits abroad. Until 1916 he moved about between properties he bought or rented in various places, but much of the time he lived at Kragerø, a small coastal town facing an archipelago of wooded islands, where he would paint among the conifers. An increasing proportion of his pictures dealt on the one hand with scenes from working-class life and on the other from his own. He had already painted many self-portraits; now they multiplied, revealing him in various moods and situations. The two tendencies were not as opposed as might be thought, for the interest in workers did not only stem from radical political views, it also came from self-identification as a 'worker of the world.' After his breakdown work became for him a therapy and artistic creation a substitute for the sexual procreation he had renounced.

During his months in the clinic and in the following year Munch finally received substantial recognition in his native country. Much to his gratification despite his republican sympathies, he was made a knight of the Royal Norwegian Order of St Olav; he had quite strong patriotic feelings. Successful exhibitions were held in Christiania and Bergen. The National Gallery, now directed by Jens Thiis, bought a number of works and accepted the gift of a striking collection of Munch paintings from Olaf Schou. And a great collector of Norwegian art, the Bergen merchant Rasmus Meyer, who had until recently shunned modernism, rapidly acquired an almost equally important group of his works. With his new interest in the working class, Munch renewed a concern he had long had for the dissemination of his art among the people by means of the mural decoration of public buildings. He hoped and believed, in fact, that the day of 'dealers' pictures,' small paintings intended to be hung on the walls of well-to-do middle-class homes, would soon be over, to be replaced by a public art available to all – a prediction since partially realized, if in a way very different from that Munch had visualized. As the Christiania municipality, to his chagrin, never favored him in the way it did his former friend with whom he had quarreled, the sculptor Gustav Vigeland – by taking over all his work and furnishing lavish facilities for exhibiting it permanently – the Frieze of Life was never a practical possibility. But in 1909 Munch entered and won a competition for the decoration of the new Aula, or assembly hall, of Christiania University. The scheme comprised three huge and eight smaller canvases, treating allegorically the theme of 'the powerful forces of eternity.' He set to work immediately, but as there

Left: Munch in 1911 in front of a version of *The Sun* (pages 88-89).

Below: *The Champagne Girl*, by Hans Heyerdahl, c. 1880-81. The subject is related to Munch's *The Day After* (page 56-7).

Right: Munch painting in his open-air studio. Munch frequently left his canvases exposed to the elements for long periods which accounts for the poor condition of many of them now.

Below right: *Gerhard Munthe* by Christian Krohg, 1885. Munch's teacher Krohg may have influenced Munch's conception of portraiture (e.g. pages 23, 38, and 59).

was still considerable conservative opposition to his art, final approval was not won until 1914, and then only through strenuous efforts by his friends, particularly Thiis. By then the work was largely finished. It was unveiled in 1916. Five years later another opportunity came with a proposal to decorate the dining rooms of the Freia chocolate factory. Only one part of the original idea was executed, a frieze of twelve paintings for the employees' canteen, completed in 1922. In the late 1920s, with a good deal of public encouragement, he worked on designs intended for the new Oslo City Hall, chiefly scenes of construction workers and snow diggers, but no commission ever came; by the time the building was begun in 1931 his eyesight was impaired and he was no longer strong enough to undertake so large a job.

In 1916 Munch had bought the large house and estate called Ekely, at Skøyen, close to Christiania, and here, except for brief interludes, he lived for the rest of his life, from time to time adding studios as the need arose. Without turning into a recluse, he withdrew to some extent from social contacts, guarding his privacy and in general discouraging visitors. But until he grew too old he still traveled abroad occasionally, especially in the early 1920s, and enjoyed visiting Oslo and attending exhibition openings. He appears to have become attached to some of his young female models, notably the beautiful Birgit Prestøe (page 102). His habits were a trifle eccentric. While sometimes he would dress and behave with conventional formality, his surroundings can only be described as slovenly: only two or three rooms in the big house were put to domestic use, every other room was left dusty and untidy, with paintings, drawings and prints stacked or strewn helterskelter. He liked to paint outdoors, even in winter, and had an open lean-to studio built for the purpose. Sometimes he would leave paintings outdoors, exposed to wind, rain and snow, which accounts for the poor condition of many. This careless treatment was deliberate – he did not believe in spoiling 'his children,' which was the way he thought of them; the practice seems to match his often apparently careless style of painting.

In 1930 a burst blood vessel in the right eye almost extinguished his vision. The disorder yielded to treatment but was never completely cured. From now on his activity diminished somewhat, though he continued to work to the end of his life. When the Germans invaded Norway in 1940 Munch refused to associate with them or their Norwegian collaborators. He died of a heart attack in January 1944, soon after his 80th birthday, and thus did not live to see the country liberated. All the work remaining in his possession he

bequeathed to the City of Oslo, where it is now mainly housed in the Munch Museum: 1008 paintings, 15,391 prints, 4447 drawings and watercolors, 6 sculptures and a large collection of manuscripts and letters. He had disliked selling his paintings and kept the bulk of them, both because they were 'his children' and in the hope, realized in 1963, that after his death the City of Oslo would establish a museum for them. By the sale of prints alone he had been able in later years to generate a large income, one reason why he produced so many.

Nowadays it is a commonplace to group Munch with the patriarchs of modernity, with Cézanne, Gauguin, Van Gogh and Seurat, 'the last of the great post-impressionists,' as one writer described him. To be sure, he influenced some younger artists, notably the German expressionists, but to stress his importance as a 'pioneer' of modernism is to misunderstand his art. Just as Raphael, an

eclectic who borrowed from predecessors and contemporaries, brought the humanistic tradition of the Italian Renaissance to one of the peaks of its development, so Munch, also an eclectic, did something similar for the realistic-romantic tradition of the nineteenth century. For a long time he seemed to be turning his back on realism, whereas actually, on a deeper level, unlike some of the avant-garde contemporaries from whom he borrowed what he needed, he was not rejecting but extending it, adding rather than substituting a new dimension of subjectivity.

Next to his tragic and harrowing family circumstances, Munch was most fundamentally affected by his Norwegian background. With respect to painting his heritage was far richer than is generally realized. Beginning with the romantic landscapist J C Dahl, Norway produced a succession of gifted painters still little known outside the country, some direct followers of Dahl, others adherents of the more conventionalized romanticism of the Düsseldorf school. Two of the landscape painters, Peder Balke (1804-1887) and Lars Hertervig (1830-1902), who became paranoid, anticipated Munch's expressionist tendencies, while a third, the short-lived August Cappelen (1827-1852), produced haunting effects of melancholy and death in forest scenes, as did Munch over fifty years later. I use the term 'expressionism' in a broad sense, to mean the deliberate distortion of natural appearances for the sake of emotional effect by artists trained to reproduce them accurately. Turning to contemporary influences, that of the Christiania Bohemia was of decisive importance. Late in life Munch stated that it was this milieu that shaped his attitudes rather than his second bohemian experience in Berlin in the 1890s. The rebellious ideology of Jaeger and his followers was probably encouraged by the conservatism and bigotry of the Christiania 'people of condition,' as they were called, consisting largely of professionals, merchants and government officials (manufacturing was still of minor importance; as late as 1900 only 3% of the Norwegian population worked in factories). The Christiania bourgeoisie was small, narrow-minded, provincial, and in religion somewhat swayed by the puritanism and fundamentalism of the Haugean movement within the established Lutheran church. Such a society bears no comparison to the enormously larger, more heterogeneous and cosmopolitan bourgeoisie of Paris or London. Very likely it was this extreme narrowness that provoked the equally extreme reaction represented by Jaeger's revolutionary views on political, social, religious, moral and artistic questions. Munch was all the more aware of the antithesis because it was personified by people to whom he felt close,

his father on the one hand and Jaeger ('I loved him but I also hated him') on the other. It may be a source of the concern with dualities that came to dominate the content of his art: objectivity and subjectivity, life and death, love and hate, individual and group, egotism and concern for humanity, bourgeois and proletarian, the attraction versus the fear of women, and their generative versus their destructive powers.

Of equal relevance to Munch's practice was the artistic doctrine of so-called naturalism – more accurately a species of individualistic realism – preached by Jaeger and Munch's *de facto* teacher, Christian Krohg. According to them the artist should represent only what he has himself experienced. His art should therefore be autobiographical. It was equally his duty to ensure that it should be intelligible, so that the emotions which activated it could be re-experienced by a wide audience who would profit from his insights. Munch absorbed these ideas and on the whole adhered to them through his career. He had a bardic conception of the duty of the great artist (in which category he included himself) to edify society, his teaching at this time to replace obsolete religion. And only by exploring his own psyche could he help others to explore theirs. He was aware that many people would find it difficult to understand some of his didactic pictures but believed that if assembled in the form of a frieze their thematic relationship would be recognized, which would help to clarify their respective meanings. As I have already indicated, the pictorially decorated secular temple was a nineteenth-century idea; it was quite foreign to most twentieth-century modernists, with their emphasis on form or self-expression at the expense of universal communication, and its espousal by Munch is a significant way in which he differs from them. With regard to the portrayal of personal experiences, it is true Munch soon moved away from naturalistic representation in the direction of expressionism, but if the portrayal of such experiences is widened to include symbolic, allegorical or expressive constructions which they have suggested, he did not infringe naturalistic doctrine but only extended it. If we consider his output as a whole its autobiographical bias is obvious, and would be so even without the evidence of around seventy self-portraits.

In fact the realist-naturalist doctrine had already planted the seeds of a new subjectivity. Since the reason for the artist's painting what he had himself witnessed was to be able to convey to others the feelings he had experienced during his act of re-creation, it behooved him to choose subjects that had moved him in the first place. Jaeger stated that his bohemian

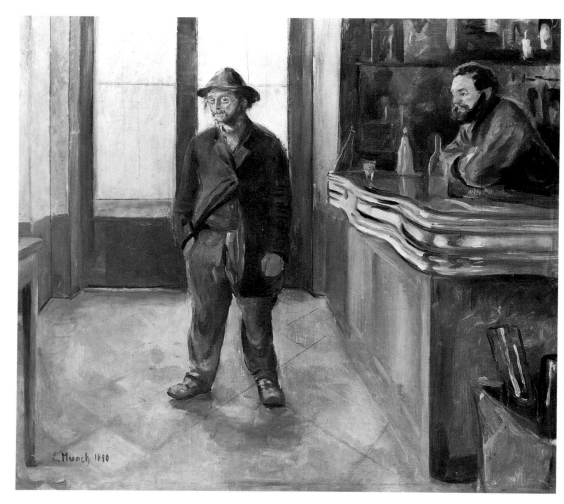

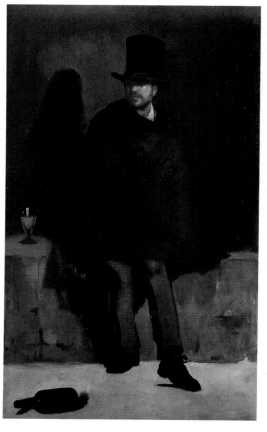

novel had been written with his 'heart's blood,' a metaphor Munch later repeated with variations. To achieve such intensity it was necessary to prune irrelevant and distracting details, and to impose a subjective unity on the relevant components retained; the objective world as interpreted by many artists of the mid-century had tended to become an accumulation of disunited particulars, perhaps partly as a response to chaotic economic growth and its attendant social fragmentation.

Krohg, on whose style of the 1880s Munch's early work was to some extent based, had lived in Paris in 1881-82 and been affected by Jules Bastien-Lepage, Manet and the impressionists. They contributed to several of his distinctive qual-

Top: *In the Tavern* by Edvard Munch, 1890.
Above left: *The Struggle for Existence*, by Christian Krohg. Munch shared Krohg radical views but his representations of suffering are usually mental rather than physical.
Above: *The Absinthe Drinker* by Edouard Manet, 1858-9. Munch's brushwork became noticeably freer after he was exposed to Manet's work in 1885.
Above right: *The Deathbed of the Worker* by Hans Heyerdahl. Heyerdahl at his best pointed the way for Munch to a deeper insight into human personality than either Krohg or Manet could provide.

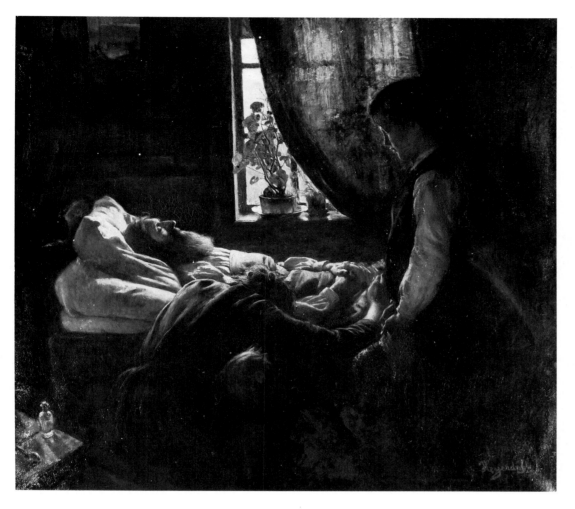

ities: bold, confident brushwork, entailing a slurring of detail and some uncertainty of structure, a beautiful sense of fairly high-keyed color, and a concern for humanity (he rarely painted landscapes). Frequently he painted subjects about which he felt strongly but which usually did not affect him personally, to wit the lives of the poor and on occasion their sufferings due to the injustices of society. Munch sympathized with Krohg's radical views. With his more introverted character and the tragedies of his home life, however, he was driven to deal mainly with sufferings of a more mental nature, both his own and those of others. The expression of these demanded a more subjective treatment, an internal realism to complement the external, which first appears unmistakably in *The Sick Child*. The most obvious catalyst in this change was his direct exposure to the art of Manet in 1885, which gave him a licence for looser, freer handling and a capriciousness of structure, and which released his inborn tendency toward an apparently casual, even slipshod treatment of anything but essentials. Less obvious but also important was the effect of his slightly older contemporary Hans Heyerdahl, a gifted Norwegian painter trained in the Munich school of realism, whose art Munch admired even many years later after they had quarreled. Besides influencing him in tangible matters of theme, composition and handling, Heyerdahl at his best pointed the way to a deeper insight into human personality than either Krohg or Manet could provide

for Munch.

Benefit though he did from the various artistic movements he encountered in Paris after arriving in 1889, Munch retained his independence, using only what he could get from these new styles that would further his own aims. The impressionists were the first to attract him. By attempting to paint momentary sensations of sight instead of objective facts they took a decisive step in the direction of subjectivity. Their researches into the effects of light on color produced more saturated color patterns and more vivid contrasts. Their endeavor to record instantaneous perception obliterated the distinction between sketch and finished picture. These achievments were valuable for Munch, but there were other aspects that could not have appealed to him. Discarding traditional chiaroscuro in favor of color contrast precluded forceful effects of relief. Subjectivity was procured at the expense of objectivity. Impressionism did not unify the scene portrayed but merely replaced a multitude of naturalistic details with a multitude of dabs of color which the mind of the observer could then translate into such details. Its insistence on ocular perception alone devalued subject matter, resulting in the avoidance of any narrative or drama, and of any composition other than the apparently accidental, since deliberate composition would emphasize the cognitive value of what was painted. The logical end was anti-humanistic, because it would involve absorbing the human figure along with other objects into purely visual patterns

of colored light. Besides, matching their bright colors and avoidance of drama the impressionists largely confined themselves to painting the sunny side of life, including the leisure life of the Parisian bourgeoisie, hardly the sort of topic to attract Munch.

No doubt for these reasons he quickly abandoned impressionism. For a short time he flirted with the pointillism or neo-impressionism of Seurat and his followers, which disciplined the free brush-strokes of impressionism into a cluster of colored spots of more or less uniform size systematically arranged according to theories of color contrast and combination. Munch painted a few excellent pictures related to this style (e.g. page 34) but never adhered to it rigorously and soon dropped it, though a trace of its influence occasionally re-appears in later years. Pointillism imposed a clearer structure than impressionism but was even more concerned with the analysis of visual perception and (despite Seurat's late experiments with the expressive values of rising and falling lines, and colors) almost equally hostile to the expression of strong emotions. And it involved too mechanical an operation to suit Munch's temperament.

What did have a lasting effect on him was the symbolist movement, particularly that variety of it sometimes called synthetism, initiated by Paul Gauguin and Emile Bernard and practiced by the Pont-Aven painters and the group called the Nabis. Symbolism was originally a literary movement, associated with such poets as Munch's friend Mallarmé. In art it meant, rather vaguely, the portrayal of scenes of such a type and in such a way that they would imply more general meanings underlying external appearances. Synthetism dealt more specifically with the representation of scenes whose components were governed by memory or imagination instead of immediate observation; in other words, mental instead of ocular images, conceptions instead of perceptions. With the synthetist painters, as with the primitive art they admired and were influenced by, this tended to produce simplified forms and the reduction of the scene to a static flat pattern; our mind's eye tends to forget details, to see things fixed rather than in motion, and in the flat rather than in the round. A two-dimensional pattern requires relatively unmodulated areas of color enclosed and separated by lines, which may be either negative, that is to say formed naturally by the juxtaposition of different color or light values, or positive, which means actual drawn lines added to emphasize the separation of the color areas. The synthetists used both types but favored the positive, which contributes to greater unity, emphasizes the

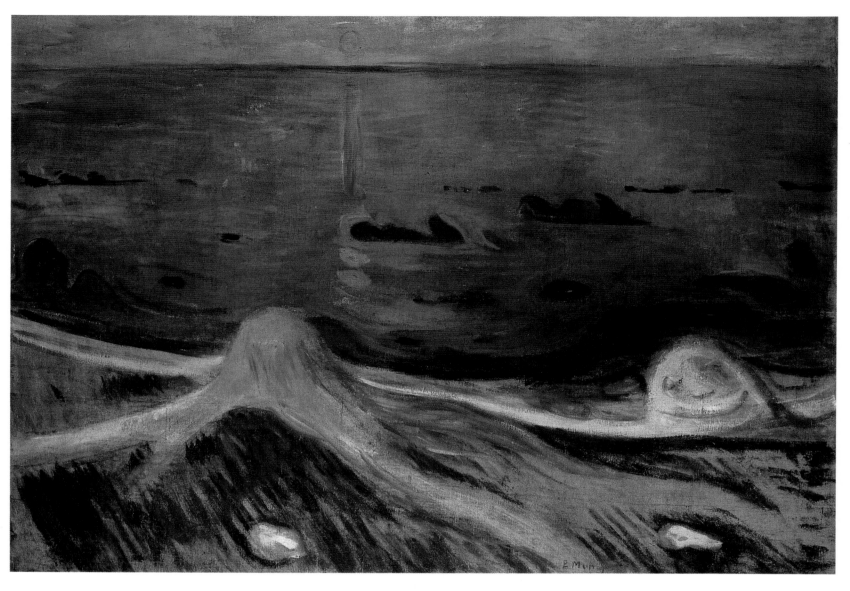

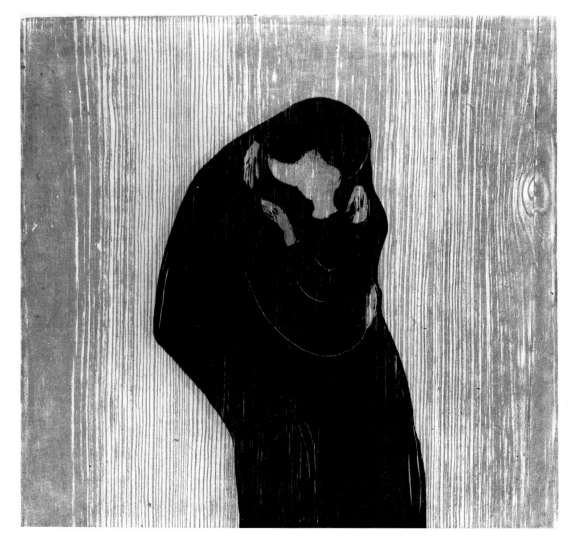

conceptual image, and is in any case much easier (to produce a strong color pattern with negative lines alone requires the skill of a John Sell Cotman). Their choice of colors was determined not by naturalistic fidelity but by the emotional charge added to the subject by memory and association. In his work of the 1890s Munch utilized this new subjectivity, unity and freedom of color, although his color schemes were relatively subdued to suit the somber themes of death and suffering that had already gripped him and were now reinforced by the pessimism of the bohemian circle in Berlin, who also encouraged him to dwell on sex relations and his complicated attitude to women.

Symbolism, however, was opposed to Munch's early commitment to Norwegian naturalism which, for all his avowals to the contrary, never wholly deserted him. Out of the conflict between these disparate modes he was able to endow his allegorical constructions, based on his own experience, with a vitality usually lacking in synthetist art. A clue to how this was achieved can be found in his posing of the human figure. He often favors frontal or profile positions. These views, normal in primitive art, harmonize with flat pattern construction because they suggest planes parallel to the plane of the pattern, whereas intermediate views do not. But for Munch their significance was

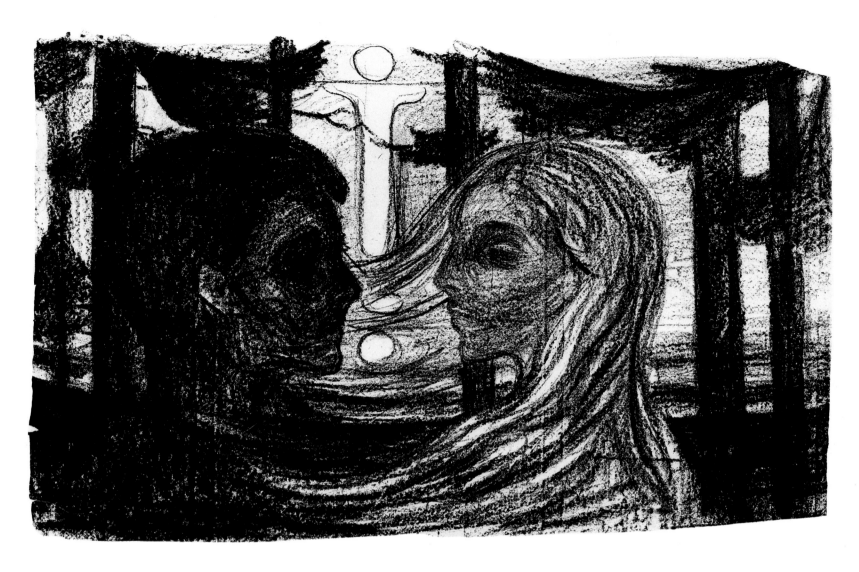

much greater. More than other views, they provide unambiguous, readily recognizable contours which detach the figure from its environment, isolating it as a discrete image and thus expressing human loneliness, one of his perennial themes. He rarely represents direct intercourse except by physical contact, in which case the pluralism of figures contracts to a single image.

In other respects Munch tends to use the profile differently from the frontal position. The profile figure suggests no possibility of movement outside the plane of the pattern of which it forms a fixed part, whereas figures in frontal or dorsal positions, while not violating the pattern, can be shown suggesting movement or actually moving into or out of three-dimensional depth. Because it implies a change of distance from the observer such movement also evokes the passage of time. Even without implied movement distance in space in a picture can suggest distance in time, and thus a memory of the past. In practice Munch sometimes employed profile figures in the foreground to denote states of passive, timeless contemplation, the memory of the past which is the object of such contemplation sometimes being shown in the background (e.g. page 52). Frontal figures, on the other hand, are wedded to space and time and, especially if moving,

Above left: *The Mysticism of a Night* by Edvard Munch, c. 1892.

Left: *The Kiss*, 1902, a black and grey woodcut by Munch.

Top: *Attraction*, a Munch lithograph of 1896.

Above: *Morbid Love* by Theodor Kittelsen from his picture-book *Har Dyrene Sjael?* (Have the Animals Got Souls?), Copenhagen, 1894, based on watercolors of 1893. Though Kittelsen appears to caricature Munch's erotic paintings incorporating a phallic reflection of the sun, most of these were actually painted later.

can imply an active physical or emotional reaction to the memory image in the background (e.g. page 64). Both types allow us to be privy to the imaginative picture in the protagonist's mind. Not all of Munch's symbolic pictures belong to these categories; his huge output was too varied to be tied up in such neat formulas. But he rarely fails to animate his symbolic patterns with the dimensions of the real world. When he does confine himself to simple flat pattern, it may be assumed that the mental image is that of the spectator him or herself.

Another important aspect of Munch's mature work of the 1890s is his treatment of line, especially the outline of the human figure. Like Gauguin and his school, he often used positive lines, but handled them in a freer manner. They are often fragmentary and usually irregular, arbitrarily changing in thickness, consistency and color. Occasionally they widen into streams of color, so that the distinction between the linear and the painterly, never conspicuous, disappears entirely. Sometimes Munch detaches the positive contour from the object it encloses, thus separating the form from the material substance of what is depicted, and sometimes he suggests flexibility and movement by doubling or further increasing the outlines surrounding figures. If spread out widely, as is sometimes the

17

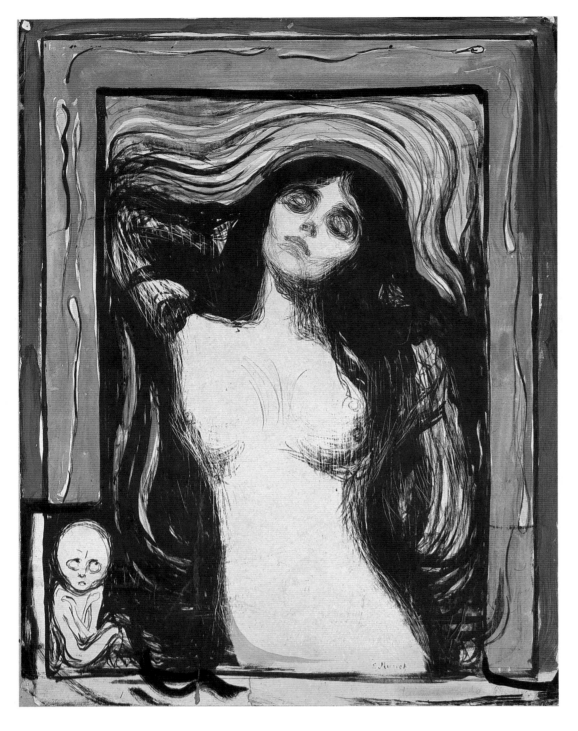

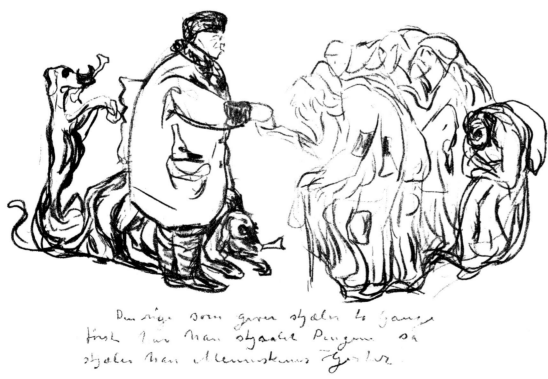

case, such multiple contours create a kind of visible linear aura emanating from the figure. The effect of these liberties is to integrate the objective and the subjective and to create a dream-like mobility that seems to indicate firstly, that images, however discrete, interact with their environment, and secondly, that just as perception depends on changing conditions of light, as Monet was pointing out with his poplars and haystacks, so conception depends on changing conditions of mood and bias: 'The point is that one sees different things with different eyes The way in which one sees depends also on one's mood,' wrote Munch himself.

Already in the early 1890s some of Munch's simplified outlines began to take on the flowing continuity of art nouveau, or Jugendstil as it is often called in Germany and Scandinavia. This new style aimed at unifying the fractured external world by subjecting it to a curvilinear fusion whereby its disparate elements could be absorbed into a homogeneous totality. For many years, well into the beginning of the twentieth century, its influence appears in his work. Doubtless its subjective continuity and unity appealed to him; perhaps he was also affected by the fact that at a time when he was much preoccupied with the power and fate of women the graceful curves of art nouveau seemed to echo the female body, feminizing nature. But he never wholly succumbed to the style. Firstly, it involved a flat, uniform linearity at odds with his painterly leaning and naturalistic concern for three-dimensional space. Secondly, Munch was above all a humanist, and the total absorption of humanity into a continuum meant, just as in the case of impressionism, the dissolution of individual human personality; in *The Scream* (page 47) he seems to depict the struggle against this fate. Many other artists of the period, while developing anti-naturalistic styles, were loath to apply them to the human figure, which they continued to treat more naturalistically than the rest of nature. Thirdly, the scope of the art nouveau ideal of unity extended to a total environment, not merely to pictures hanging on walls. It was therefore essentially a decorative art applied to the tools of practical life, its content adapted to the form and utility of the objects it decorated, whether buildings, furniture, vases, books or other domestic objects. Pictures enclosed by frames were in fact subversive of this aim, as they created independent illusory spaces with self-sufficient contents unrelated to material utility or external decorative schemes. The Belgian Henri van de Velde, like several other typical art nouveau artists, started as a painter but, evidently realizing this, gave it up and became a designer and architect. He was a socialist, and influenced by

William Morris's advocacy of the development of arts and crafts to beautify people's daily lives. But for Munch, though he sympathized with the left, it was impossible to follow this path; he disliked all crafts, his genius was for conveying personal moods and messages by purely pictorial means. Even book illustration, a typical art nouveau art he occasionally dabbled in, was really foreign to his temperament. Gradually art nouveau forms disappeared from his work and his leftist feelings found other outlets.

This was part of a complex of changes that began to appear in Munch's art around 1900. It has been said that his breakdown in 1908 was a turning point; others have thought the shooting incident in 1902 marked the switch. But I think the process was gradual, largely independent of these traumas and clearly evident in its first stages before either of them. In any case his style in these later years is too varied and inconsistent to be discussed other than in respect to general tendencies.

Probably the most fundamental change was the gradual breakdown of the conceptual element with its stress on unity of surface pattern. Art-nouveau linear continuity is fractured into a loosely joined collection of particulars. In a way this represents a return to naturalism, or rather the sort of naturalistic expressionism that first appeared in *The Sick Child.* For Munch still distorts, simplifies and selects from nature, in fact on the whole with greater freedom than before. His art is still imaginative, but now more 'expressionist' than 'synthetist,' based more on the distortion of sophisticated perception than primitive conceptualism.

Another development is the use of increasingly brilliant colors. This has been attributed to a more extroverted attitude on the artist's part, a disposition to turn away from his own unhappiness and fears and deal more objectively and optimistically with humanity at large. The effect of Matisse and other fauve painters has also been mentioned. Neither explanation is altogether satisfactory. Munch's heightened color schemes appeared before the fauve painters created their style, and he may have influenced them before they did him. As for optimism, it is true that bright colors expel the gloom of his earlier work, and that his practical mural schemes (as opposed to the Frieze of Life, which never approached a practical possibility) present a more cheerful view of life. Certainly there was a change of attitude, a new understanding that his personal sufferings exemplified only one aspect of life. But when he is not uttering specifically public pronouncements his underlying pessimism often creeps in. Soon after Hitler came to power in 1933 he voiced his conviction that war would come and his

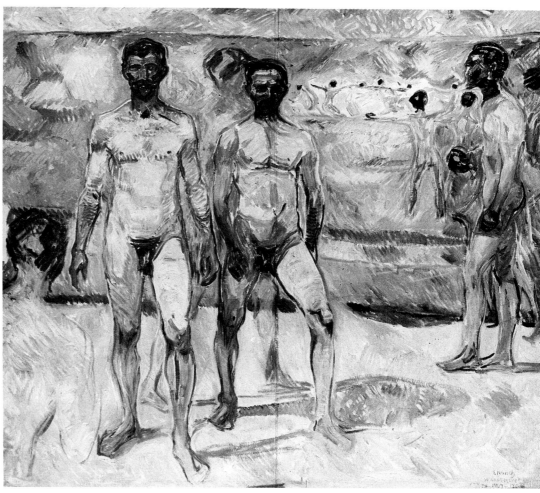

doubt that war among men could ever be eradicated. 'Mankind is a depraved race,' he remarked. He had a fatalistic belief in man's helplessness to control his destiny, which was determined by forces he was incapable of understanding. To the end of his life, hardly a smile brightens the increasingly frequent self-portraits. There could, however, also be another quite different reason for the bright colors of the later work, namely that they contribute to increased articulation; the greater range of color values and intensities made it possible to introduce more glittery contrasts destructive of surface unity.

Unlike Gauguin and other modernists, including his own followers among the

Above left: This hand-colored lithograph, *Madonna*, 1895-1902 relates to a painting of 1894-5 (page 48), but retains the sperm and foetus in the frame.

Top: *Adam and Eve*, 1908.

Above: *The Bathing Men*, 1907.

German expressionists, who were attracted to and derived forms from the conceptual art of primitive cultures, Munch, never a formalist, was unresponsive to such influences: 'he need not go to Tahiti to perceive and experience the primitive in human nature. He carries his own Tahiti within him . . .!' wrote the critic Franz Servaes, co-author of the first

book on Munch. When the conceptual image in his art evaporated it left a residue of fragmented nature which he seems to have related to what he took to be the comprehension of children and unsophisticated people. Without imitating any kind of conceptual art he 'primitivized' forms by means of drastic simplification. At the same time, around the turn of the century, he began to take a new interest in children as subject-matter for his pictures.

Beyond doubt, in his later years Munch was intent upon reaching a wide audience, children in the case of the Linde nursery (page 78), students in that of the University Aula (page 88), 'simple' working people in that of the Freia factory canteen. His enthusiasm for a public art derived from his left-wing standpoint. He took little interest in practical politics but the imprint of Jaeger's powerful personality, and hence his anarchist views, never left him. Munch thought that the rich robbed the poor (page 18, below), that the day of the bourgeoisie was due to end, and that its place as the dominant element in society would be taken over by the working class. Art was a necessary ingredient in these people's lives, to be brought to them chiefly through the decoration of public buildings. As a result, the subject matter of his art tended to shift in the direction of its intended 'consumers'; from the beginning of the century until the early 1930s, when it became clear he would never achieve his ambition to decorate the new Oslo Town Hall, he painted, drew and made prints of, a great quantity of scenes of working-class life.

It is one of the many contradictions in Munch's art that conscious though he was during the later years of a social function for art, his practice became more egocentric than ever. The basis was now naturalistic, but whatever the scene portrayed, he treated it with the utmost liberty, neglecting anything not of interest and confining himself to simplified, sketchy, loosely contoured, even ragged renderings in brilliant colors of what he evidently considered essentials. His own act of creation meant everything, it would seem, and if a picture were damaged by being trod on or exposed to the weather, this did no harm; on the contrary, it could allow his creative act to be seen in a new light, which might even improve it. Following the naturalistic doctrine of his youth, subjects remained substantially autobiographical, even more obviously so after settling down to the quieter, more secluded life at Ekely. To some extent he lived on memories, and among the most important of these were his own early pictures, of some of which he continually made replicas, especially of favorites he had reluctantly lost by selling. These replicas are not copies in an ordinary sense, they are

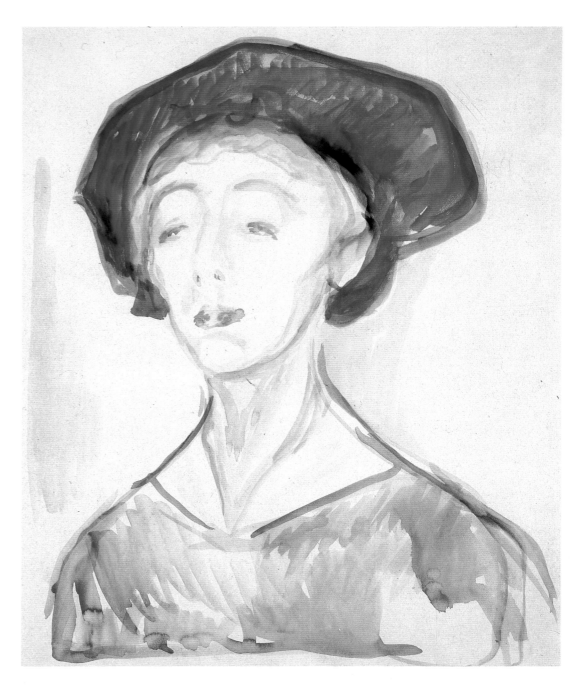

Above: *Lady with a Blue Hat*, a watercolor from 1916-18.

Below: This watercolor, *Kneeling Nude*, was painted in 1921.

Above right: *Uninvited Guests*, 1932-3. The subject may relate to Munch's shooting at Ludvig Karsten in 1905.

Right: Edvard Munch in his studio at Ekely in 1943, not long before he died.

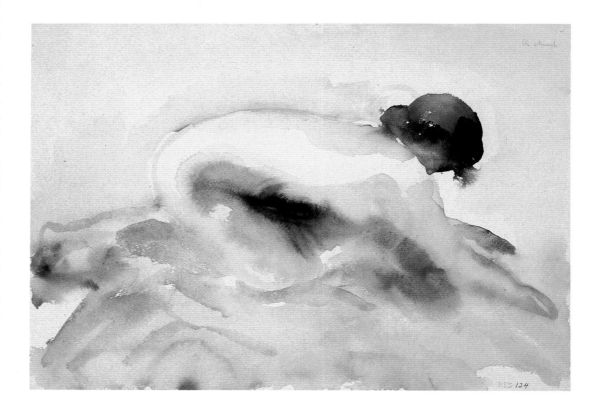

painted as though distantly remembered incidents in his life, varied, loosened, simplified, and sometimes vulgarized by the shrill colors of his later years. Now and then he would contrive new imaginative reconstructions of other incidents of his past life that had left their mark on him. As I previously indicated, even the numerous scenes of workers had a subjective tinge, reflecting his own obsession with work as the chief consolation of life. It is noteworthy that these scenes nearly always show laborers either at work or on their way to or, more usually, from it, rarely at leisure and never in their homes; home life meant little to Munch. Another significant fact is that except in earlier years he rarely depicted female workers; the emphasis is on masculinity. A similar quality appears in the pictures of male bathers and in many of the portraits of his male friends and patrons, mostly self-confident individuals, that he painted in the first decade of the new century. In all probability the trend represents a reaction, perhaps triggered by the Tulla Larsen episode, against the images of the weak male and the dominant femme fatale that pervade his work of the 1890s.

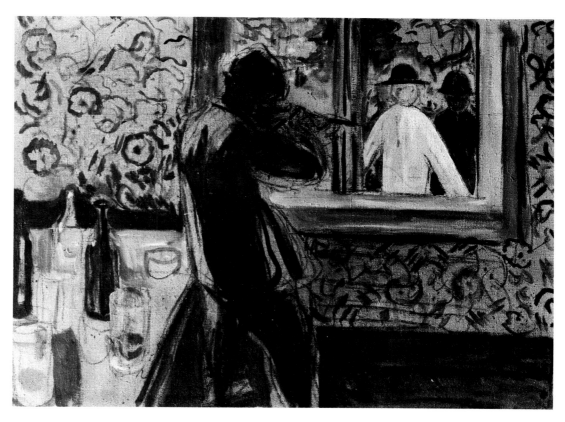

To behold Munch's late work is in many cases to be confronted with anarchy – not in the sense of the artistic result, which is often superb, but of the selection and interpretation of the data depicted. He was too much of a realist and a humanist to embrace any of the dissections and systematizations twentieth-century modernists have imposed upon or substituted for the external world. He sees the world subjectively but without trying to repudiate it, and what he sees seems to have lapsed into a chaos in which humanity and nature just manage to preserve their identities. We can only speculate as to the source of this anarchy. It seems unlikely that it could have any connection with the philosophical and political anarchism he imbibed in his youth – yet one of the very last works he ever executed was a new portrait lithograph of the long-dead Hans Jaeger. Possibly it reflects inner turmoil at the approach of death; or, more likely, a sense of social disintegration in the outer world. Whatever the cause, brilliant colors prevent the effect from being unduly pessimistic. And there may be significance in the fact that in the latest of the proletarian pictures the dominant theme is building (e.g. page 105) – perhaps symbolizing the construction of a new world.

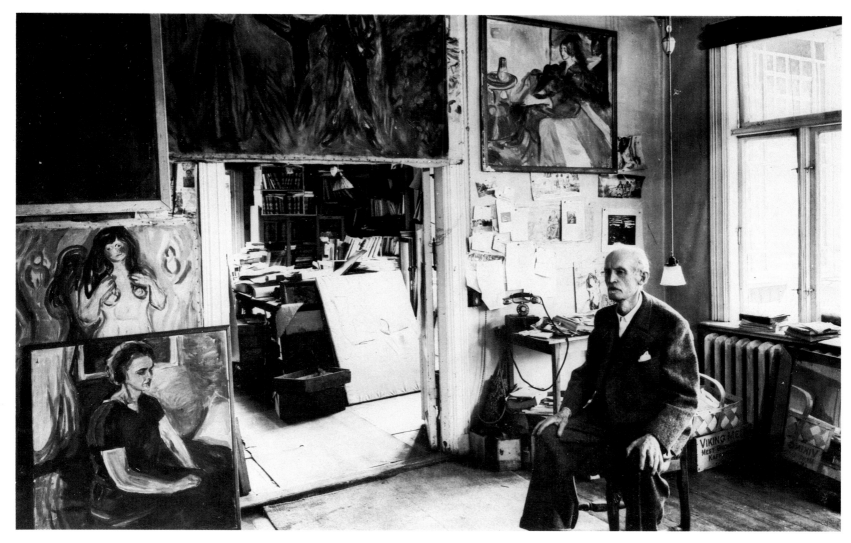

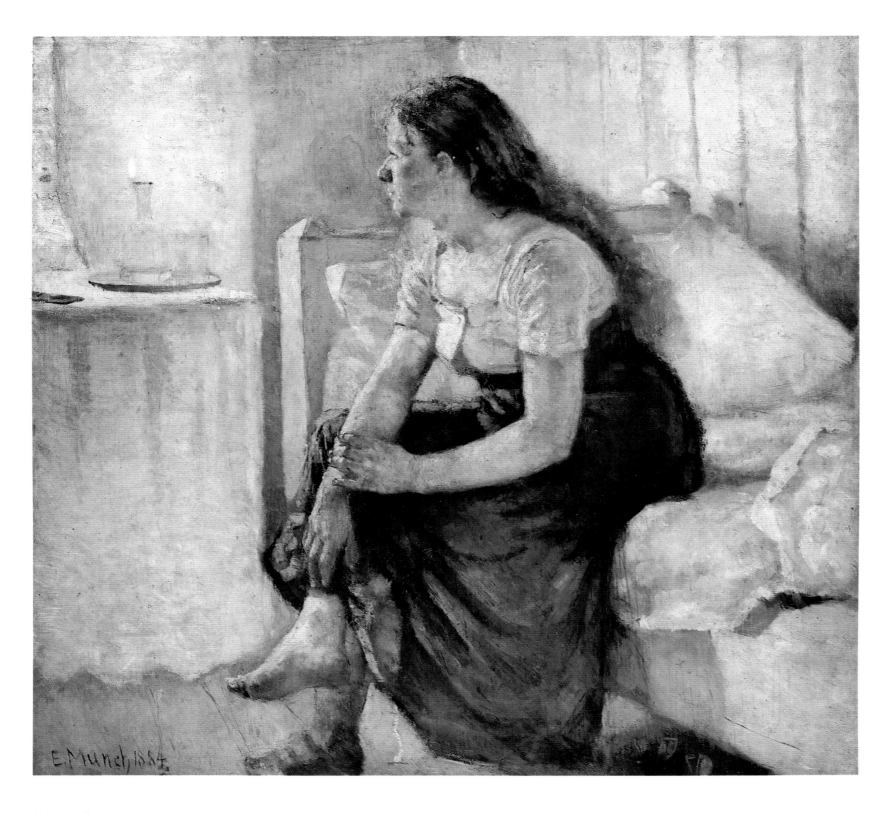

Morning, 1884

Oil on canvas
38×40¾ inches (96.5×103.5 cm)
Rasmus Meyer Collection, Bergen

With the rise of the romantic movement the theme of a woman gazing longingly toward or out of a window became fairly common in nineteenth-century painting, doubtless as an expression of the romantic quest for freedom applied to the circumscribed lives led by women of the middle class. Munch's inspiration was probably a picture by Hans Heyerdahl of 1881, *At the Window* (National Gallery, Oslo); he follows this work in using the profile view for representing a state of reverie, the device he adopted in many subsequent pictures. But whereas Heyerdahl's lady (in fact his wife) is obviously middle class, Munch has daringly translated the theme into proletarian terms, thus drawing it into the category of the 'social realism' of his teacher Christian Krohg. Color and execution are closer in some respects to Heyerdahl than to Krohg, whose bold, assured brushwork usually makes of light no more than a function of the mass it illuminates. Munch, on the other hand, makes light in this picture an independent and determinative factor, allowing it to shatter surfaces and hence, in the case of the girl herself, to seem to penetrate to her inner being. Her face kindles with a sort of lyrical eagerness, emphasized by the bend of her body toward the magnetic light from the almost unseen window. Already in this early masterpiece we see Munch moving away from the objectivity of most contemporary naturalism towards a revelation of internal reality. Small though the step may appear in the light of later developments, it was enough to offend the critics when the work was exhibited at the Fall Exhibition in 1884. They considered it slapdash.

It might be noted that Munch disliked painting hands and ears. In later years he would scornfully mention fingernails as an example of the irrelevant details it behooved him to ignore. In this and a few other early pictures, however, he painted them.

Karl Jensen-Hjell, 1885

Oil on canvas
74¾×39⅜ inches (190×100 cm)
National Gallery, Oslo

Among the conflicting elements in
Munch's character was a strain of bravado
in contrast to his fears and timidity. It
came to the fore in the production of this
portrait, which might well be deemed
arrogant, firstly because it is the work of a
very young painter exploring an artistic
area, the full-length, life-sized portrait,
largely outside the Norwegian tradition,
secondly because the picture itself ex-
presses arrogance, an almost caricatured
swagger with offensive bohemian over-
tones. No wonder the conservative critics
disliked it.

Karl Jensen-Hjell (1862-88) was a
wealthy bohemian painter who died very
young. He had been a fellow-pupil with
Munch at Thaulow's open-air academy at
Modum in 1883.

Munch did have one important Nor-
wegian precedent: Krohg's 1882 portrait
of the liberal politician *Johan Sverdrup,*
also in its way a work of considerable dar-
ing. And as *Jensen-Hjell* was painted after
his first brief visit to Paris, he had had the
opportunity of studying the European
tradition of the life-sized full-length. His
picture has echoes of Velásquez, whom he
encountered at the Louvre. The use of the
cane may derive from Manet's *Théodore
Duret* of 1868; the pose also recalls this
work, and is even closer to several male
full-lengths by Whistler and Courbet.

However much it depends on such
models, *Jensen-Hjell* is a tour de force of
imaginative construction. He stands close
to the picture plane, and the distance of
the artist's station point is short. The eye
level is quite low, around the middle of
the picture. This necessitates a wide verti-
cal angle of vision to encompass the
height of the figure and the space above
and below it. The result is that the whole
figure appears magnified into a convex
curve, with the face foreshortened from
below and the feet from above. Jensen-
Hjell's body seems to push us out of the
picture space while he looks down at us
disdainfully from a greater height and dis-
tance, granting us only the condescension
of a one-eyed glance, his left eye being
hidden by a reflection in his pince-nez.
His hauteur is touched with comical
irony by his bohemian aspect. Even lean-
ing on a walking stick his pose might seem
unsteady, but it is stabilized and given
confidence by the pressure point of hip
and hand against the stick being made to
correspond approximately with the junc-
tion of the dimly seen intersection of
walls and floor in the background, and by
the horizontality of the cigar.

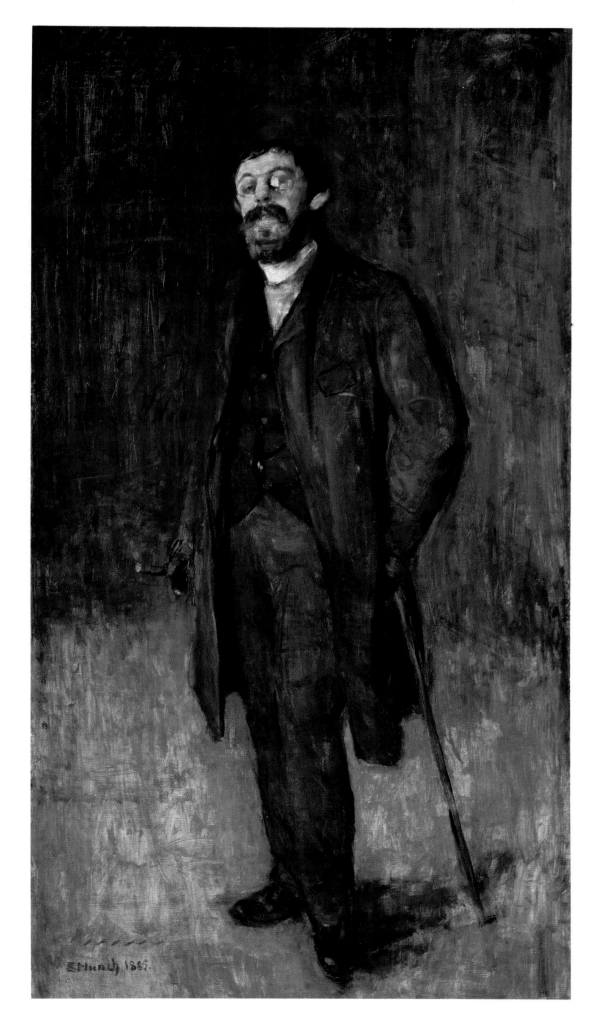

23

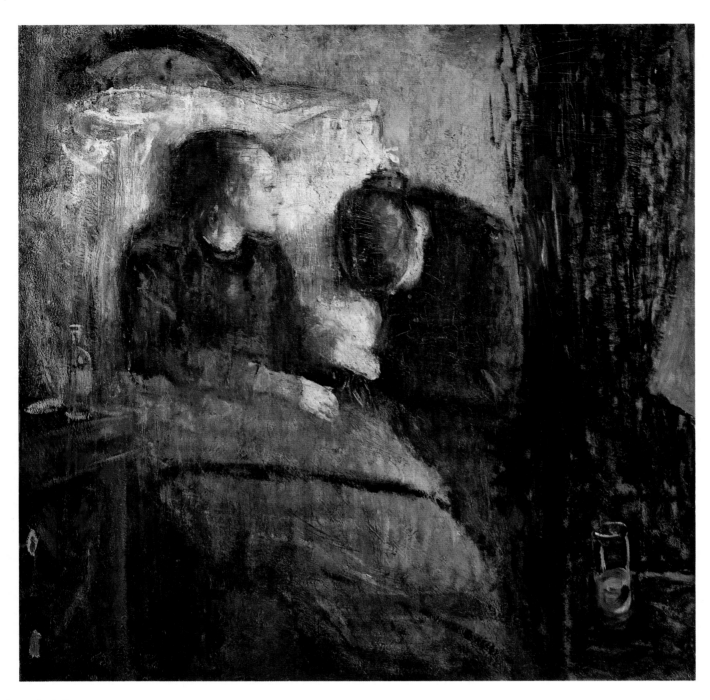

The Sick Child, 1885-86

Oil on canvas
47×46⅝ inches (119.5×118.5 cm)
National Gallery, Oslo

Whether because of waning religious faith, a sense of social decay, or a combination of such pessimistic stimuli, scenes of sickness and death became common in the late nineteenth century. So Munch had many models on which to base this subject. But he believed his picture differed from others of the sort in that it was based on personal experience of a childhood home racked by sickness and death. Specifically the picture records the fatal illness of his sister Sophie (in fact modeled by an 11-year-old girl called Betzy Nielson), the sorrowing woman being their Aunt Karen.

When it was exhibited in 1886, to the shock and scorn of most viewers, he called it a *Study*, probably because he doubted that it conveyed the intensity of his initial vision. Subsequently he repeatedly worked on it, worrying it with repainting, dribbled paint (later obliter-

ated), scratching and scoring, giving the picture a variegated surface. As a result, the scene now appears as though viewed through a dense haze that obscures structure and detail; it seems idealized by being made into a distant, dream-like apparition.

Munch believed the picture marked a turning point in his art, that it 'provided the inspiration for the majority of my later works.' To some extent he was right: intense feeling, expressionistic freedom of color, sketchy raggedness of execution, disregarding surface finish, all are qualities that continually re-appear.

A physical link, the joining of the hands, expresses the love that unites the two figures. These hands have no separate identity but are fused into a single mass of flesh-tinted paint, so that in a sense sufferer and griever become one. Munch emphasized the importance of the join by

placing it exactly in the center of the almost exactly square canvas, and by having the foreshortened lines of the dresser on the left point at it. Yet on a higher psychological level the two are separated, each absorbed in her own immediate emotions. The woman bends her head downward, expressing the depth of her sorrow, while the sick girl in profile looks yearningly across her toward the window, thus repeating with greater intensity the theme of *Morning* (page 22). Her pale face and fiery red hair against the white pillow, painted with turbulent impasto, create a feverish atmosphere of sickness. The expression on her face seems to convey spiritual exaltation as she approaches death. As with *Morning*, she and we are shown nothing of what lies beyond the window towards which she so intently gazes; the dark curtain intervenes and the realm of death remains unknown.

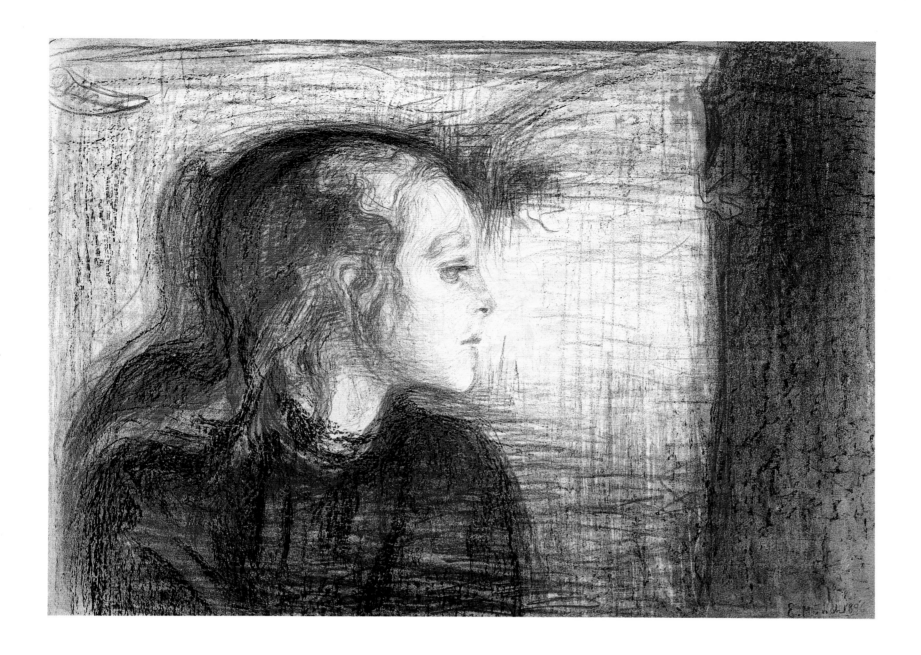

The Sick Child, 1896

Lithograph, Sch. 59
16⁹⁄₁₆×22¼ inches (42.1×56.5 cm)
Munch Museum, Oslo

The Sick Child was one of Munch's favorite subjects. Over the years he painted at least six versions, besides executing it in drypoint and etching. This lithograph, done ten years after the original painting (page 24), he had printed in various color combinations.

Here he changes the emphasis. The woman, together with all the incidentals that made the painting into a genre 'scene,' is omitted; he concentrates entirely on the magnified head of the child and the death she approaches, doubtless symbolized by the curtain, which is now moved closer to her, into the place formerly occupied by Aunt Karen. At the same time the clotted, painterly handling of the picture is translated into a flowing linear idiom, tinged with the Art Nouveau influence of the 1890s. Instead of passively awaiting the inevitable, the girl meets her end dynamically, propelled by elegant flowing lines towards the dark curtain on the right. What might be a fringe of her hair flies out and almost touches the curtain, in the same way that Munch at this time frequently used women's hair to designate a sexual bond; sex and death were intimately connected in his mind. A tusk-like form at the upper left, representing nothing but which the fanciful observer might consider phallic, also points rightward. Even her features slope more in this direction. Between girl and curtain, the background shading consists of horizontal lines seeming to issue from the former which cross verticals echoing the latter, producing an agitated area of cross-hatching.

Puberty, 1894-95

Oil on canvas
59⅝×43³⁄₁₀ inches (151.5×110 cm)
National Gallery, Oslo

This picture repeats a composition of the mid-1880s lost through fire. To what extent it remains faithful to the original can only be guessed, but the style has a good deal in common with the realism of the previous decade. The pose could have been suggested by a Félicien Rops illustration, published in 1886, for Barbey d'Aurevilly's *Les Diaboliques.* A nude adolescent girl, sitting on her bed in a bare room dimly lit from the left, suddenly becomes aware of the approach of womanhood. Her frontality and centrality give her the quality of an emblem. She deflects her tightly closed legs away from the light, as if to protect them from its probing. Her broad face with its huge almond eyes seems to express a mixture of eagerness, fear and bewilderment; the projecting ears exaggerate the width of the face, making it seem to bulge with expanding cognition. While the top of her head is rounded, the outline of the lower jaw and chin is a little more pointed, and this configuration is amplified and exaggerated in the curve of the shoulders and the arms pointing downward and crossed over the genital area, at once both indicating and concealing. Thus mind and sex appear joined. Behind her rises a large amorphous shadow that seems to emanate from her private region. Such shadows were sometimes used by Munch to depict a kind of sinister alter ego, varying in shape and import with the needs of the subject. The source of the idea was probably Manet's *Absinthe Drinker* (page 14). In the case of *Puberty* the pear-shaped shadow may allude to the uterus, of whose function the girl has now become conscious.

For Munch *Puberty* was a step into new territory. In choosing such a subject he must have been influenced by the intense concern of Jaeger and his circle with sexual ethics. As in *The Sick Child* he achieves his effect by expressionistic modifications of naturalism. While maintaining a basically realistic structure he aims at 'internal' realism instead of external. With the aid of his neurotic sensibility he intuitively understands the thoughts and feelings of those he depicts, and by taking liberties with color, form and atmosphere, allows them to qualify outer appearances. But whereas *The Sick Child*, for all its expressionism, conforms to the accepted iconography of realism, *Puberty* deals with a subject rarely before treated in art. Moreover it was, in its original version, his first truly symbolic subject, in the sense of representing something more abstract than what is shown. *The Sick Child* contains symbols of sickness but is not in itself symbolic; it is *the* sick child, not 'childhood sickness.'

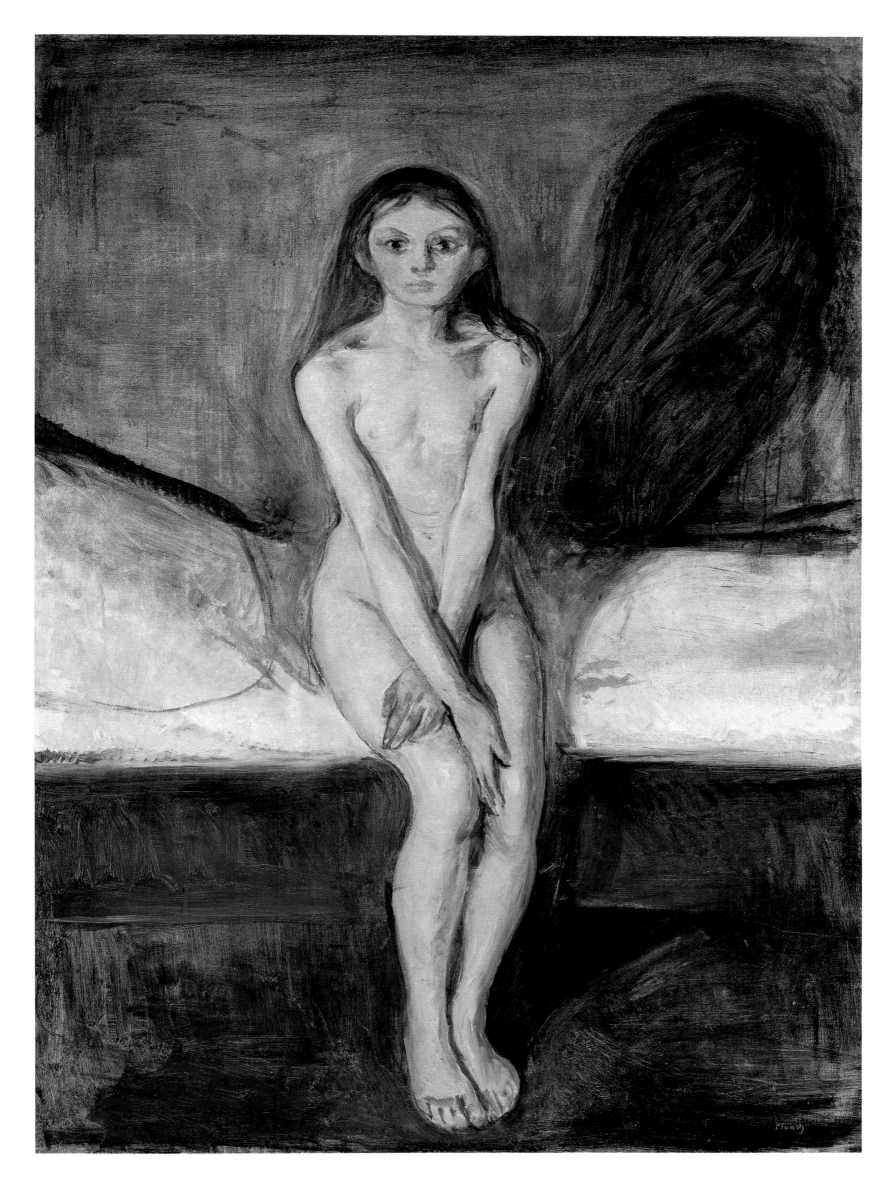

Village Shop in Vrengen, 1888

Oil on canvas
17½×27⅛ inches (44.5×69 cm)
Lillehammer Bys Malerisamling,
Lillehammer

Late in the 1880s Munch produced several pictures rather more carefully and conservatively painted that those of the mid-decade; perhaps he did so to tone down his reputation as a rebel, with an eye to obtaining the state scholarship he was awarded in 1889. The most conspicuous of such pictures is *Spring* (page 7), the largest he had so far painted, which was favorably received.

Village Shop in Vrengen is unusual in being a classically composed genre subject carrying no obvious personal or emotional burden. The girl behind the counter, however, is modeled on his sister Inger and the man with the long pipe on his father. It is painted much in the manner of Krohg, with a particularly Krohgesque color scheme emphasizing blues and pinks. Krohg was a regular summer visitor at the Danish artists' colony at the fishing town of Skagen, and the subject is of a type favored by the Danish realist-impressionist painters who congregated there. In particular it is reminiscent of a qicture of 1882 by P S Krøyer, *In the Grocer's Shop When There is No Fishing*, which Munch may possibly have seen during his visit to Copenhagen in 1888.

Traditional though this picture may appear, it contains a new feature of importance for the artist's later development: the use of a perspective recession, here much emphasized by the floorboards, in conjunction with a figure in the extreme foreground truncated by the base line. The construction was not original with Munch but he used it later in highly personal ways to suggest memory and the passage of time.

Vrengen is a small village south of Oslo on the west side of Oslo Fjord.

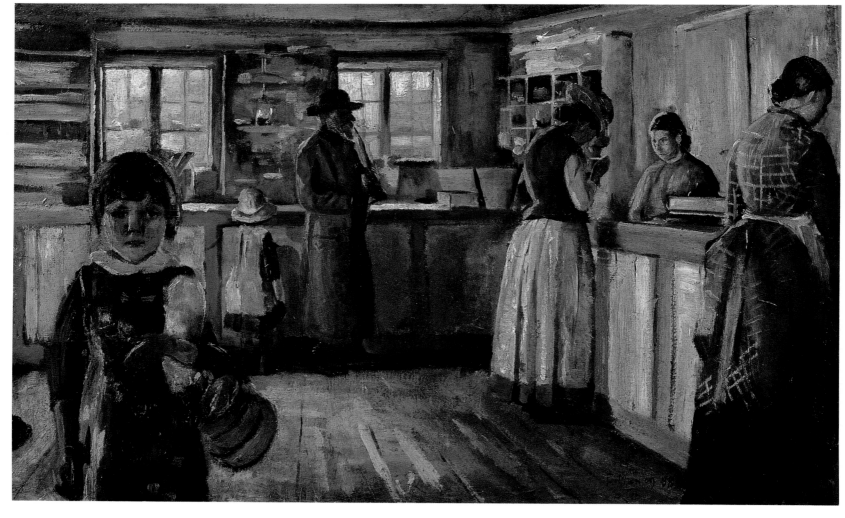

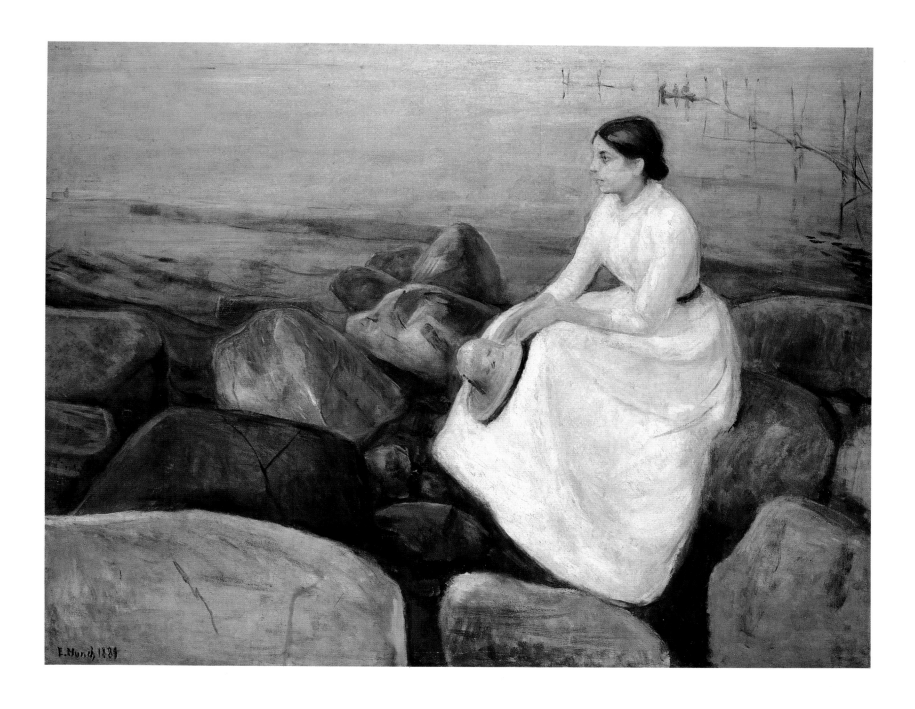

Inger on the Beach, 1889

Oil on canvas
49¾×63¾ inches (126.5×162 cm)
Rasmus Meyer Collection, Bergen

Inger Munch (1868–1952) was Edvard's youngest sister and only sibling to survive him. Besides painting several portraits of her, he often used her as a model in his earlier years.

When first exhibited this picture provided another shock for the Christiania art audience, who had never seen anything like it. It is a mood painting, producing an effect of isolation and, although an outdoor scene, confinement. The hard rocks stand around Inger like jailers. Munch must have known the work of Courbet, in whose landscapes rocks are

often used to express the hardness of nature and provide a sort of protective custody for the ego. Here the shut-in effect is increased by tilting the sea upwards, thereby cutting out the horizon and sky. In conjunction with the striking silhouette of the white figure, this flattens the scene, anticipating Munch's symbolist paintings of the 1890s. In fact the sea would appear as a flat backdrop were it not for the perspective of the fishing trap and tiny boat with three figures that extend into it. They further enclose the figure of Inger and at the same time pro-

duce a limited sense of recession; the effect is not unlike that of some Japanese screen paintings.

Inger's pose is very similar to that of the heroine of *Morning* (page 22), but whereas that working-class girl responds to the strong light from the window, Inger receives no such external stimulus. She is bathed in the soft, diffused light of a Norwegian summer evening, lost in her own inner thoughts or memories. As already noted, Munch was prone to use stationary profile figures to represent timeless contemplation.

Hans Jaeger, 1889

Oil on canvas
43⅛×33 inches (109.5×84 cm)
National Gallery, Oslo

Hans Jaeger (1854–1910), anarchist, atheist, revolutionary social and sexual moralist, and theorist of autobiographical realism, was one of the biggest influences on Munch; his lifelong affection and admiration for the man shines through in this portrait. Jaeger sits relaxed in a shabbily furnished room with his coat tightly buttoned up and wearing a hat. Possibly this indicates that poverty forces him to live through the cold Christiania winter in unheated rooms. Or it could suggest that he is ready to leave; that he is an outsider who does not belong, with no place in the society he condemns and wishes to destroy. He had lost his minor government job and been twice imprisoned for publishing his confiscated bohemian novel. He spent much of his later life in Paris.

The rude table, with its lonely glass of *pjolter* (whisky and soda), sets him at a distance, imparting both dignity and humility. Its hard perspective lines, continued and contrasted by the soft, wavy articulations of the coat, point to his head. The right side of the face, receiving the light, seems to express humor and hope, the left, in shadow, sorrow and suffering. Whatever the interpretation, we are conscious of a complex, philosophical mind. Worthy of note is the placement of the arm on the arm of the sofa, from which the hand elegantly droops. It was a pose traditional in the portrayal of aristocracy and high-ranking ecclesiastics, going as far back as Raphael's *Angelo Doni* and especially favored by Van Dyck. To Jaeger it lends an air of casual authority in striking contrast to the humbleness of his setting.

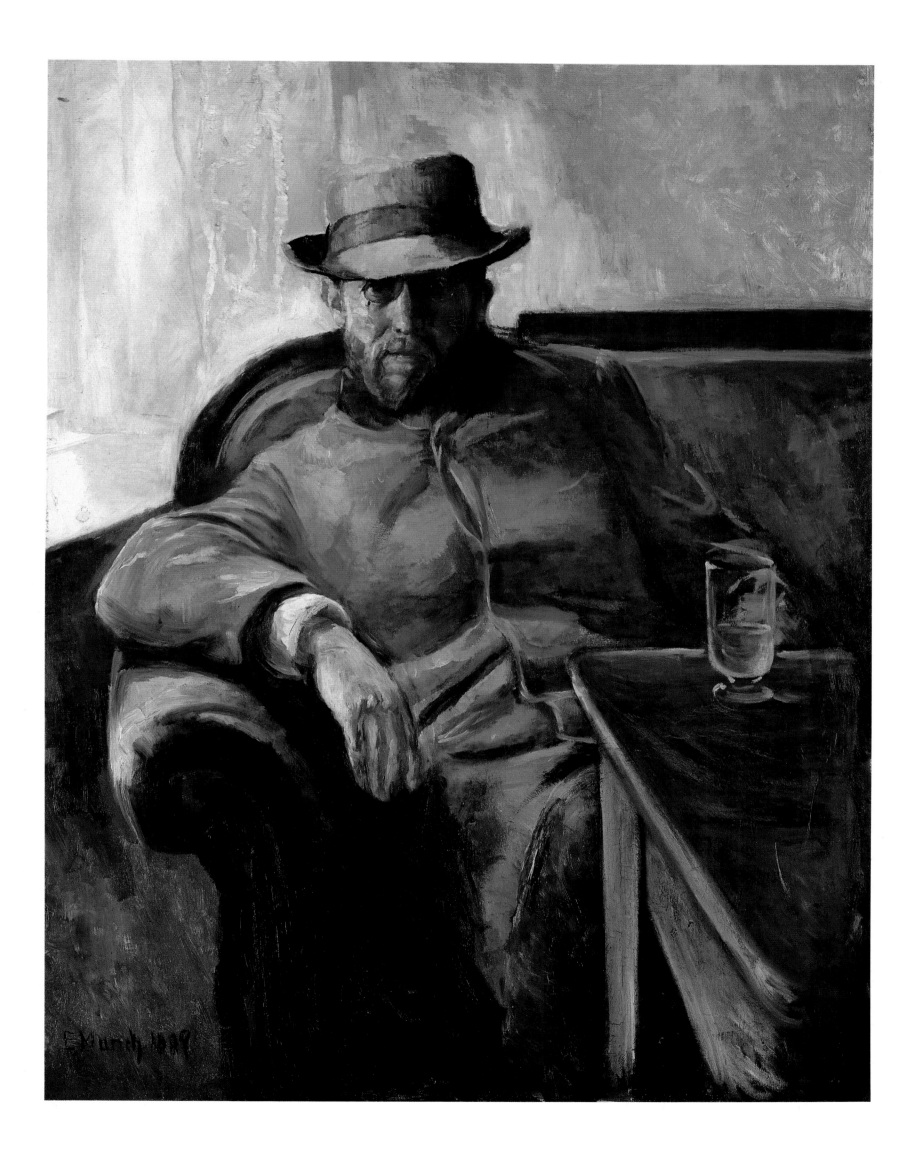

Night in St Cloud, 1890

Oil on canvas
25⅜×21¼ inches (64.5×54 cm)
National Gallery, Oslo

Some of the numerous influences to which Munch was exposed on coming to Paris can be discerned in this picture, including the modulation of blues in a night scene from Whistler, the perspective of the room from Van Gogh, the short parallel brush strokes from him, Cézanne and many others, the view of the river and the avoidance of positive lines from impressionism, and the silhouetting from Seurat or Toulouse-Lautrec. The scene shows Munch's room at St Cloud overlooking the Seine. The seated figure is his close friend the poet Emanuel Goldstein, probably depicted in the capacity of the artist's own alter ego. Solemn interpretations have been applied to the picture, notably that it expresses his sorrow at the recent death of his father, symbolized by the shadow of a cross on the floor cast by the window frame. On the other hand, Munch himself wrote of sitting by this window admiring the moonlight scene outside, and in another version of the subject the man appears to be smoking a pipe, an act usually expressive of contentment. Again we are confronted with a profile figure in passive meditation, and unless explicit information is given elsewhere in the picture or in its title it is impossible to be sure of what he or she is supposed to be thinking or what ulterior meanings may be attached to the scene. Munch was too impulsive and mercurial a character for his voluminous written and spoken comments to be a reliable guide. The fact that many of his works can be interpreted in widely varying ways by different observers, all equally gripped, points to the richness and complexity of his art.

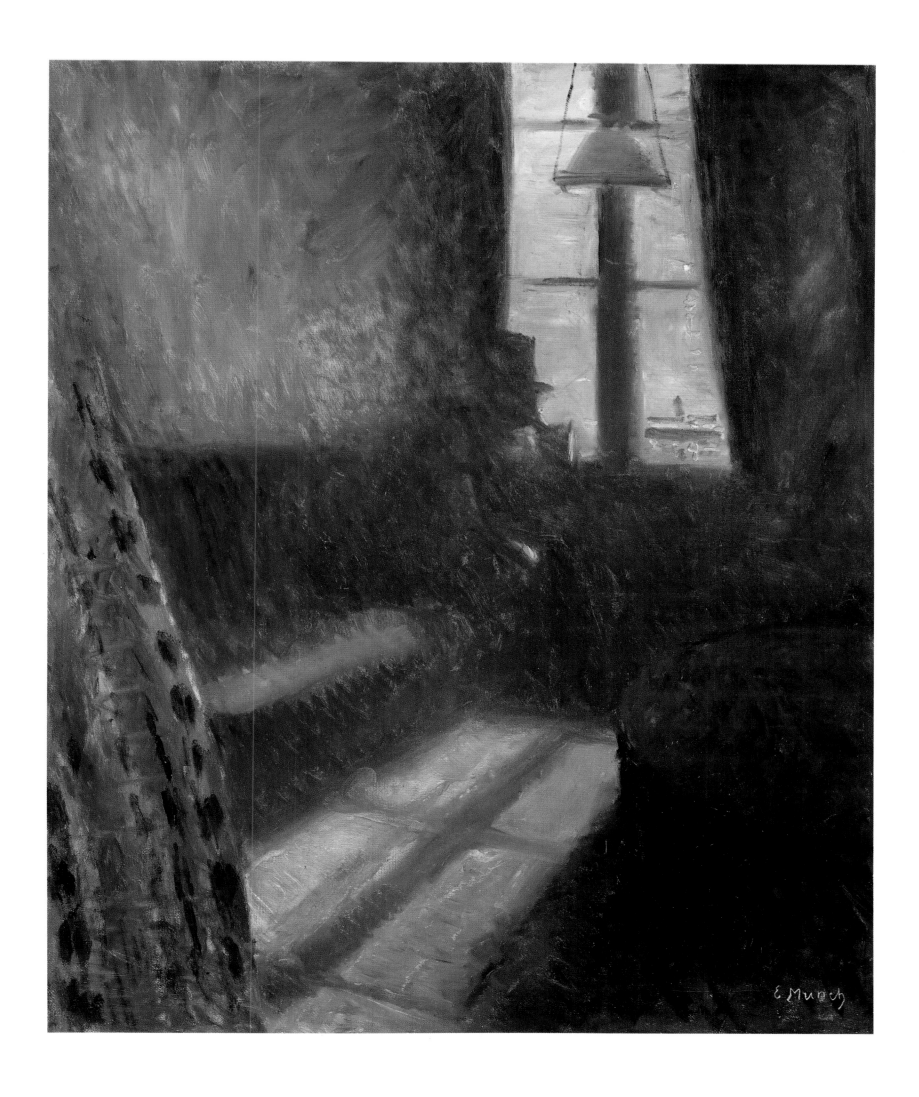

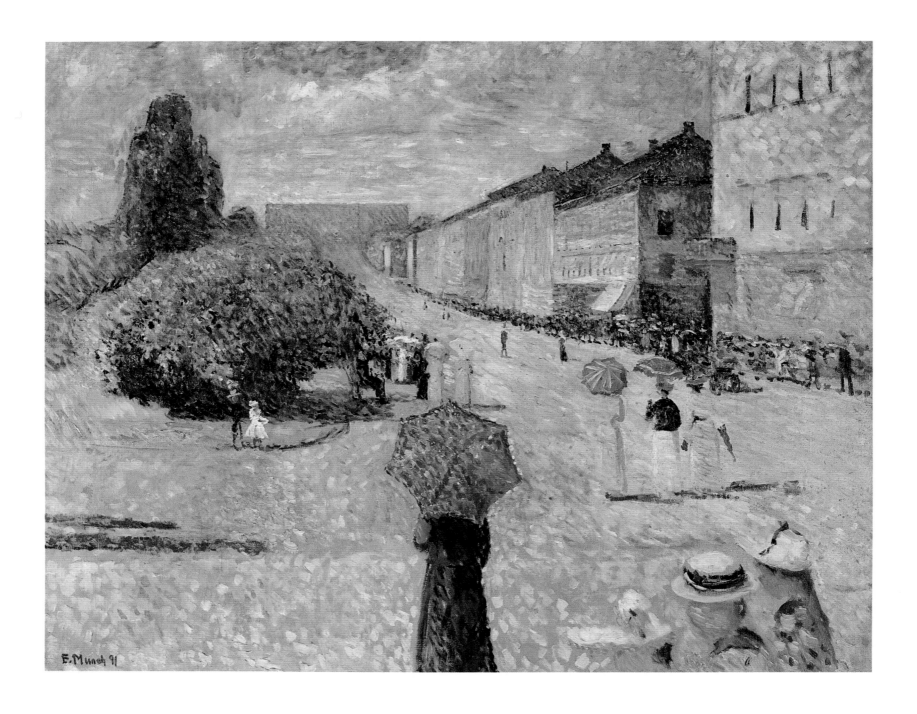

Spring Day on Karl Johan Street, 1891

Oil on canvas
31½×39⅜ inches (80×100 cm)
Bergen Billedgalleri, Bergen

Rue Lafayette, 1891

Oil on canvas
36¼×28¾ inches (92×73 cm)
National Gallery, Oslo

Like other gifted artists, including Pissarro and Van Gogh, Munch was briefly attracted to the neo-impressionism or pointillism of Seurat and Signac, whereby the brilliant, sketchily applied colors of impressionism were disciplined into carefully controlled patterns of shimmering, multi-colored spots of paint, to be blended by the observer's eye. Here he applies the method, rather loosely, to a subject typical of impressionism but rare for Munch, in fact inimical to his serious artistic goals: the happy leisure life of the bourgeoisie.

Karl Johan Street was Christiania's fashionable main thoroughfare. Munch

paints it looking toward the Royal Palace, with the Grand Hotel, a center of the city's artistic and intellectual life, on the extreme right (cf page 7, top left). He skillfully employs a construction he used later for very different purposes, a synthesis of flat pattern and plunging perspective, with truncated figures in the extreme foreground. The inclusion of sunshades or umbrellas in such a scene probably derives from a picture by Krohg of 1882, *Village Street at Grèz*. It is worth noting how the mass of foliage in the middle ground roughly repeats and amplifies the shapes of the sunshades, wedding them to the larger elements of the design.

Views of Paris streets were popular with the impressionists. Monet, Renoir, Pissarro and Raffaëlli all painted them. Munch's picture is related to a balcony view of 1880 (*A Balcony*, Private Collection, Paris) by Gustave Caillebotte, whose studio he may have visited at the time he painted the *Rue Lafayette*.

But the emphasis here is quite unlike anything impressionist. The profile contemplator high up on the balcony looks down on the eccentric perspective of the street far below him, full of moving people and vehicles and joined by other streets. Parallel strokes of paint blur the busy townscape into a dizzy vision. Set

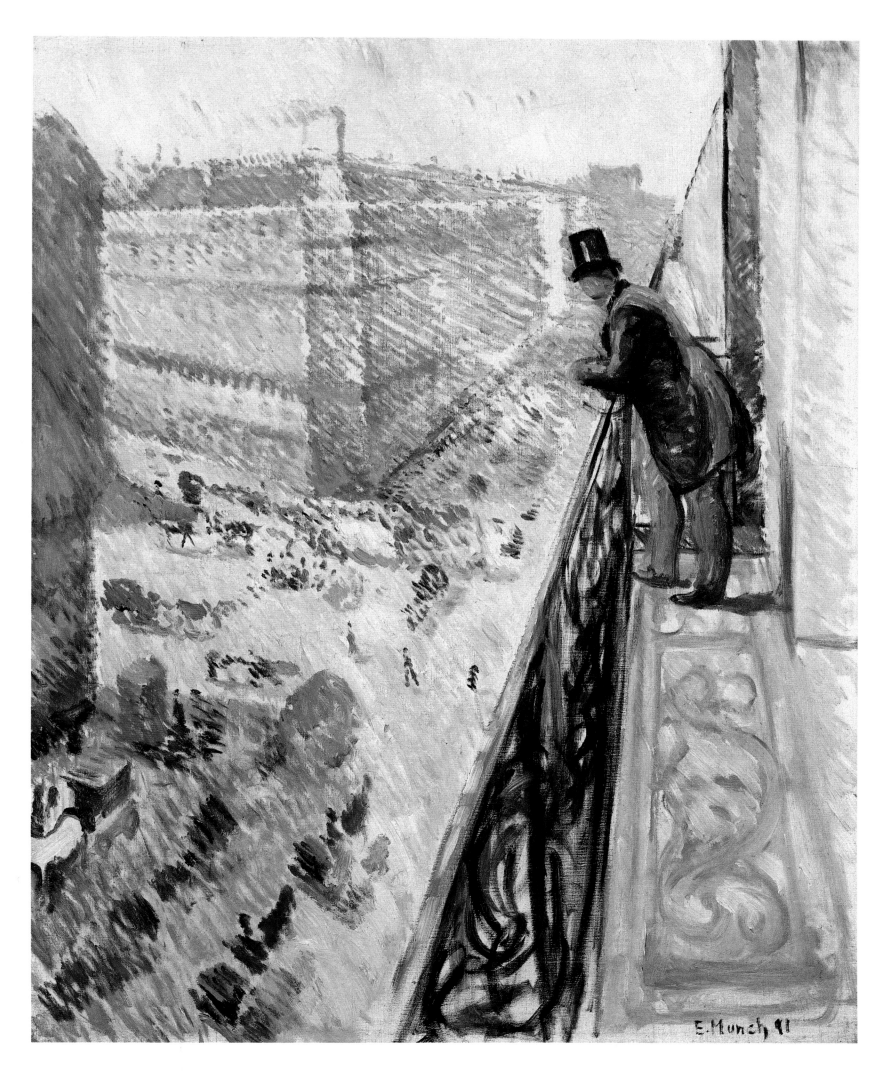

E. Munch 91

diagonally, across the man's line of sight, they exclude him from the street's activity. A contrast is created between the active and the contemplative life, existing, literally, on different levels. Munch connects this with a theme he frequently dealt with later, the antithesis of the crowd and the solitary individual. If the man followed his line of sight and joined the crowd, he would die. Our sense of his danger is all the greater because we seem to be looking slightly down at him, as though from a still higher balcony which, however, is not shown, with the result that we feel suspended in mid-air, imaginatively sharing his probable acrophobia – a condition Munch himself suffered from.

Evening on Karl Johan Street,
1892
Oil on canvas
33¼×47⅝ inches (84.5×121 cm)
Rasmus Meyer Collection, Bergen

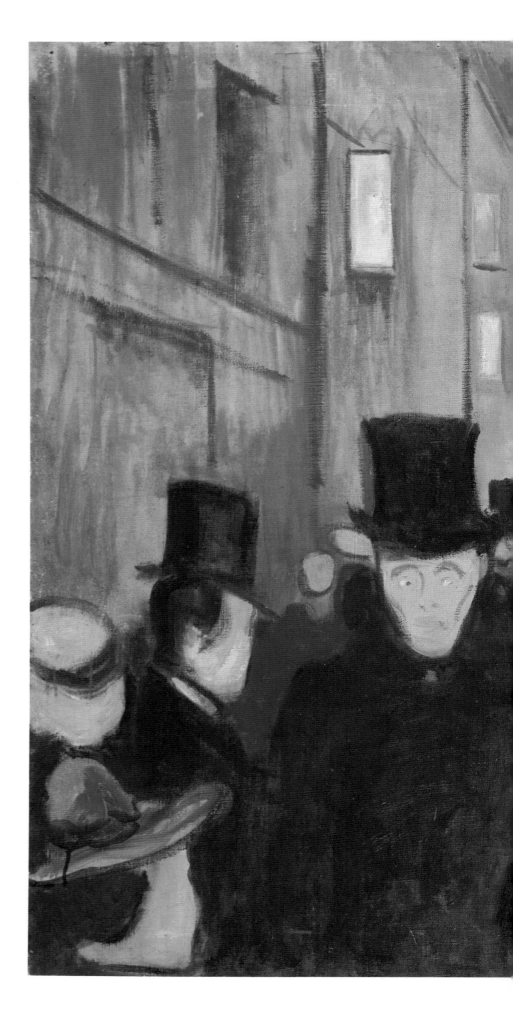

Depicting the same street a year or two later, looking in the opposite direction, and using a related pattern-and-perspective composition, Munch could hardly have produced a painting less like his *Spring Day* (page 34). He now paints in a style probably influenced by Gauguin and his followers, with simplified forms, positive lines and relatively flat areas of arbitrary color. The life of the street changes from happiness to horror. On the pavement a mass of middle-class people with dehumanized, zombie-like faces, reminiscent of the masks of the Belgian painter James Ensor, glide mechanically toward us. Although they are packed tightly, there is no communication among them; they are a lonely crowd. Out in the roadway a solitary man walks in the opposite direction, against the subhuman stream. Traditionally, and almost certainly correctly, he is identified as the artist himself. In addition to acrophobia, Munch suffered from agoraphobia; when walking he is said to have preferred to stay close to buildings. In the distance in front of him is the Storting, the Norwegian parliament, its windows lit up by ghostly lights like the eyes of some fearful presence. The scene appears to represent the horrible dilemma life presents to a sensitive individual like Munch, doomed to choose between the terror of the crowd, in which humanity is crushed, and the terror of loneliness in open spaces. Whether the Storting is to be taken as the political emblem or legislative guardian of such alienating conditions is a moot point.

The composition recalls a big picture by Krohg, *The Struggle for Existence* (page 14). A preliminary sketch for *Evening on Karl Johan Street* is even closer to Krohg's picture. Painted in a style of objective realism, the latter shows a crowd of poor people in winter receiving food from a bakery used as a welfare center, while a well-fed official-looking man, possibly a policeman or a soldier, in any case a representative of the prosperous establishment, struts alone down the middle of the street. Munch has transformed this idea in a way revealing both his debt to and difference from his teacher. Whereas Krohg shows us the material deprivation of a proletarian crowd in opposition to its successful avoidance by an isolated individual of a different class, Munch gives us the spiritual deprivation of a middle-class crowd in opposition to an unsuccessful attempt to avoid it by an isolated individual of the same class.

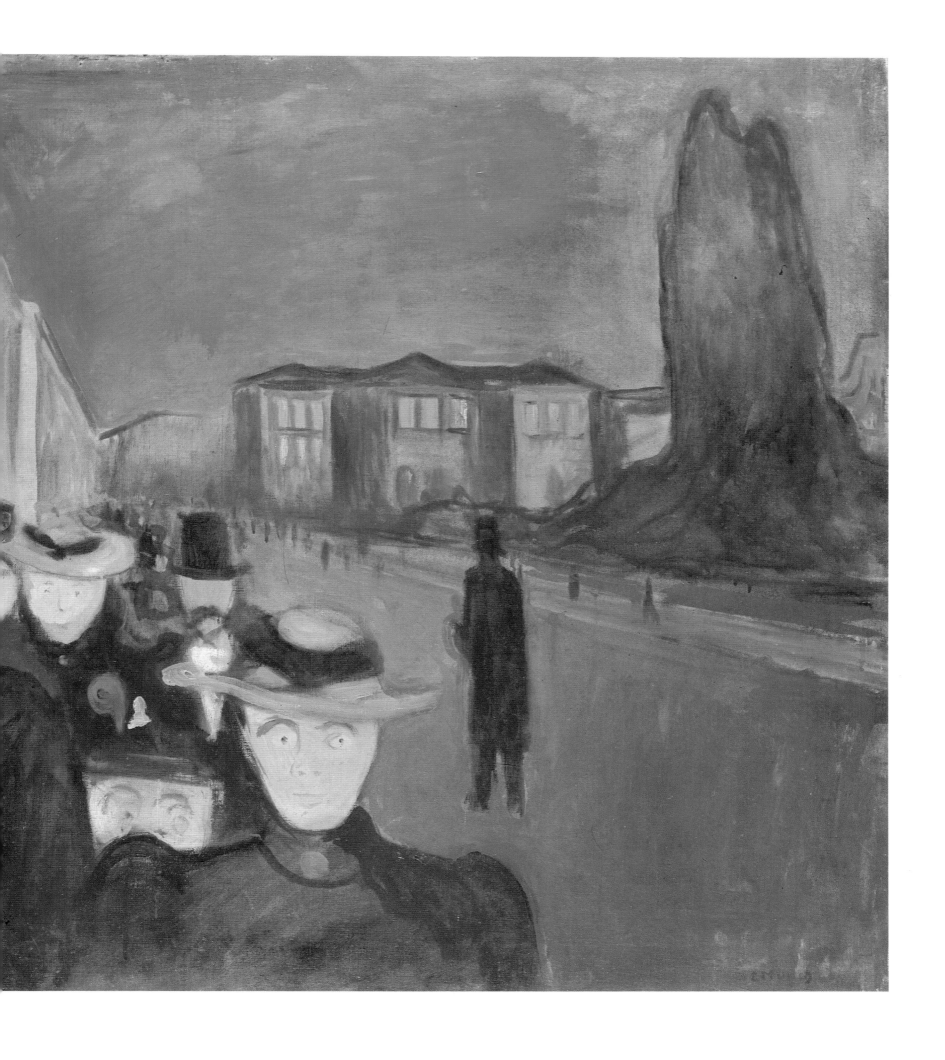

Ludvig Meyer, 1892

Oil on canvas
83⅝×41¾ inches (212.6×106 cm)
Trondhjems Kunstforening, Trondheim

Ludvig Meyer was a lawyer, a socialist who consorted with bohemian circles in Christiania. He was an early admirer and patron of Munch, one of the few who recognized that *The Sick Child* was a great painting when it was first exhibited. Munch later painted a group portrait of his three children.

This portrait demonstrates again Munch's extraordinary powers of observation and sympathetic insight, not to mention his sense of humor. Using the full-length form, he had the ability to catch a typical stance or momentary trick of poise. With legs set unheroically side by side and feet splayed, head, hat and stick tilted downward to the left, ears projecting (like Munch's own), eyes goggling, lips parted and eyebrows raised, Meyer emerges as a vivacious, almost comical, character. The man's basic lack of pretension is echoed in the simple combination of thinly painted, mottled dark and light blues and salmon pinks. To an extent the work resembles the portraits of Gauguin and the Pont-Aven school, but instead of tying up the face with positive lines into the straitjacket of a flat, stylized design, Munch models it more sensitively and in greater detail than other elements in the picture, so that it springs into three-dimensional life, independent of the flat pattern of which it is a part.

At a Students' Union meeting at which Munch had been attacked, Meyer, a witty speaker, humorously related how this 'malicious' portrait had made life difficult for him, making him feel exposed to the world and causing him to prefer the back streets for fear of encountering people snickering and nudging each other as he walked by. Then he went on to praise Munch both as a person and a great artist.

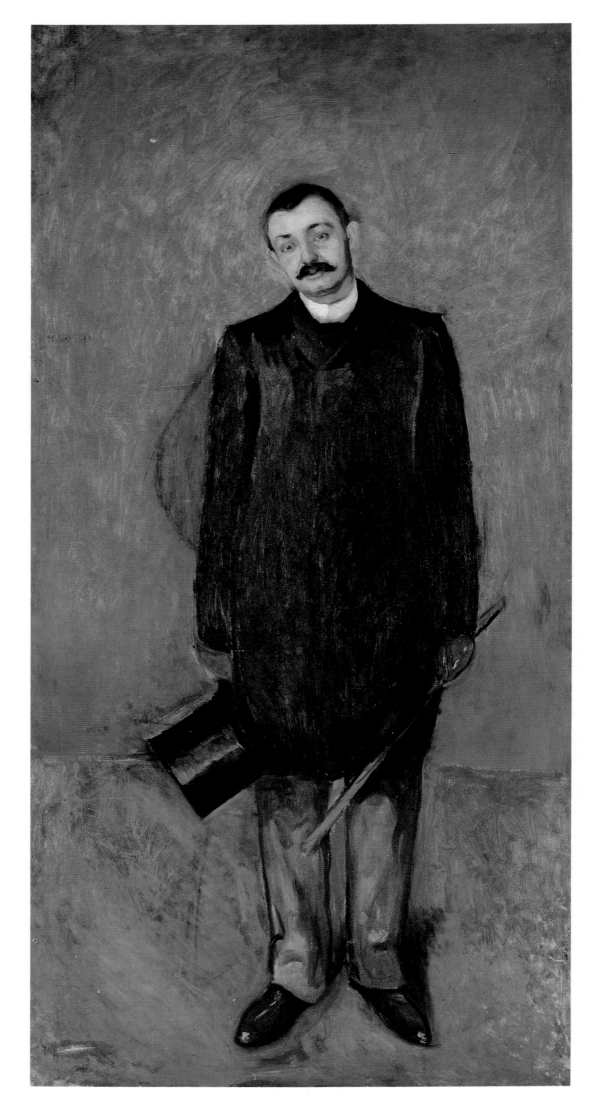

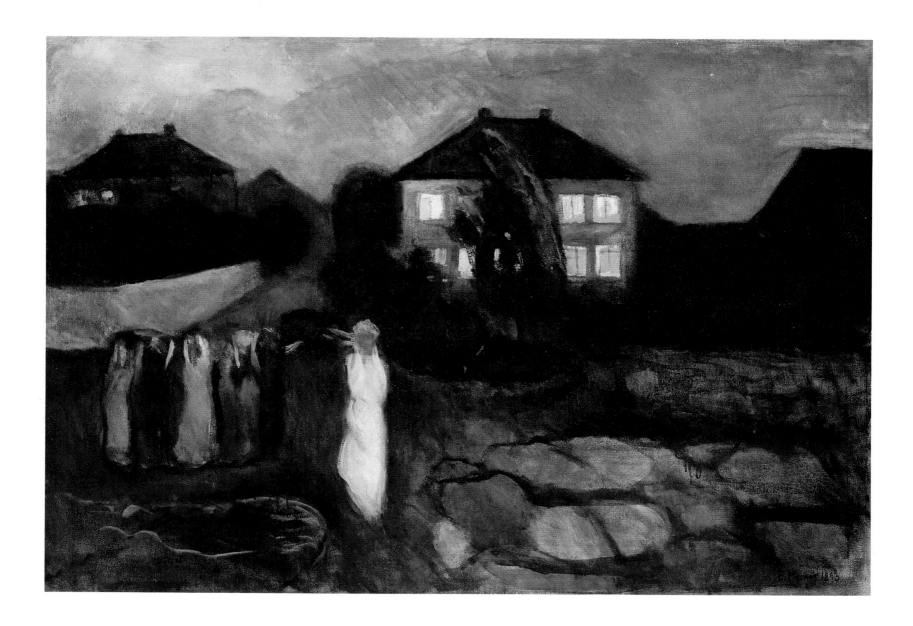

The Storm, 1893

Oil on canvas
36⅛×51½ inches (91.8×130.8 cm)
Collection, The Museum of Modern
Art, New York
Gift of Mr and Mrs H Irgens Larsen,
and acquired through the Lillie P Bliss
and Abby Aldrich Rockefeller Funds

A violent storm at Åsgårdstrand is said to have inspired this picture. The force of the wind is suggested by the bending of the central tree, continued in the cloud striations above it, and the wisps of hair blown up from the head of the woman in white. The women cover their ears with their hands, as if to shut out the whistle of the wind and the wail of the sea; the central building has been identified and stood on the coast at Åsgårdstrand. But the blurred forms, softened contours and highly atmospheric treatment give the scene a spectral quality, with the women emerging like phantoms. In consequence it is easy to conceive that nature's turbulence is intended to reflect an inner turbulence of the mind. Just what is this spiritual malaise, however, is difficult to determine. Here Munch combines several different themes he used in other pictures of the 1890s, producing an enigmatic result. Firstly, the hands placed over the ears, as in *The Scream* (page 47), probably expresses some sort of fear. Secondly, the lonely individual, the woman in white, separates herself from the crowd. Thirdly, this woman walks down the pathway through the rocks towards the sea, not shown but to be reached very soon. Munch often depicted the sea as a medium through which the light of the sun or moon would, to quote Caradoc Evans, 'call virgins to awake.' Dressed in white, this woman is clearly virginal, and storm or no storm, she must be facing the moon, else her costume could not possibly shine with such brilliance. Fourthly, there is the background building which the women have apparently left, with the tree bisecting it like a nose between quadruple eyes. In some of Munch's paintings such buildings are obviously sources of fear (cf page 64) and that may be the meaning intended here. It has been suggested that the building is lit up because a wedding feast is taking place. Were this the case, the bride would be leaving in fearful anticipation to call on natural forces to arouse sexual desire; in Munch's mind man's life was part of, and wholly determined by, the general evolution of nature, and sexual intercourse associated with fear of the inevitable cycle of life and death.

The Dead Mother, 1893

Oil on canvas
28¾×37¼ inches (73×94.5 cm)
Munch Museum, Oslo

Doubtless partly as a result of the tragedies in his childhood home, Munch's mind dwelt much on death and he painted numerous scenes of death or dying. The loss of his mother at the age of five scarred him for life and, it has been suggested, may even have contributed to the grudge he held against women, in spite of being attracted to them.

This picture was evidently inspired by his mother's death. The simple rectilinear composition is enlivened by colors unexpectedly bright for such a scene. Through the window the glimpse of a warm spring landscape contrasts with the coldness of death in the foreground. Munch was attracted to the idea of organic continuity, of the disintegration of individual life forming the basis for new life. The yellow of the dead woman's face matching the yellow of the sunlit grass outside hints at this idea, as does the fern placed on her pillow, as though it were growing out of her head. While the mother's body has lapsed into shapelessness, the head retains its structure, perhaps hinting at a more orthodox immortality.

Many years later Munch expressed admiration for a picture by Heyerdahl, *The Deathbed of the Worker* (page 15), which may have been the source for the present composition; the pose of the dead figure, reversed, is quite similar, as is the idea of the window behind. Heyerdahl's painting may also have given Munch the idea of the plants on the window-sill half-hidden by a curtain in his big picture *Spring* (page 7), also a scene of mortal illness.

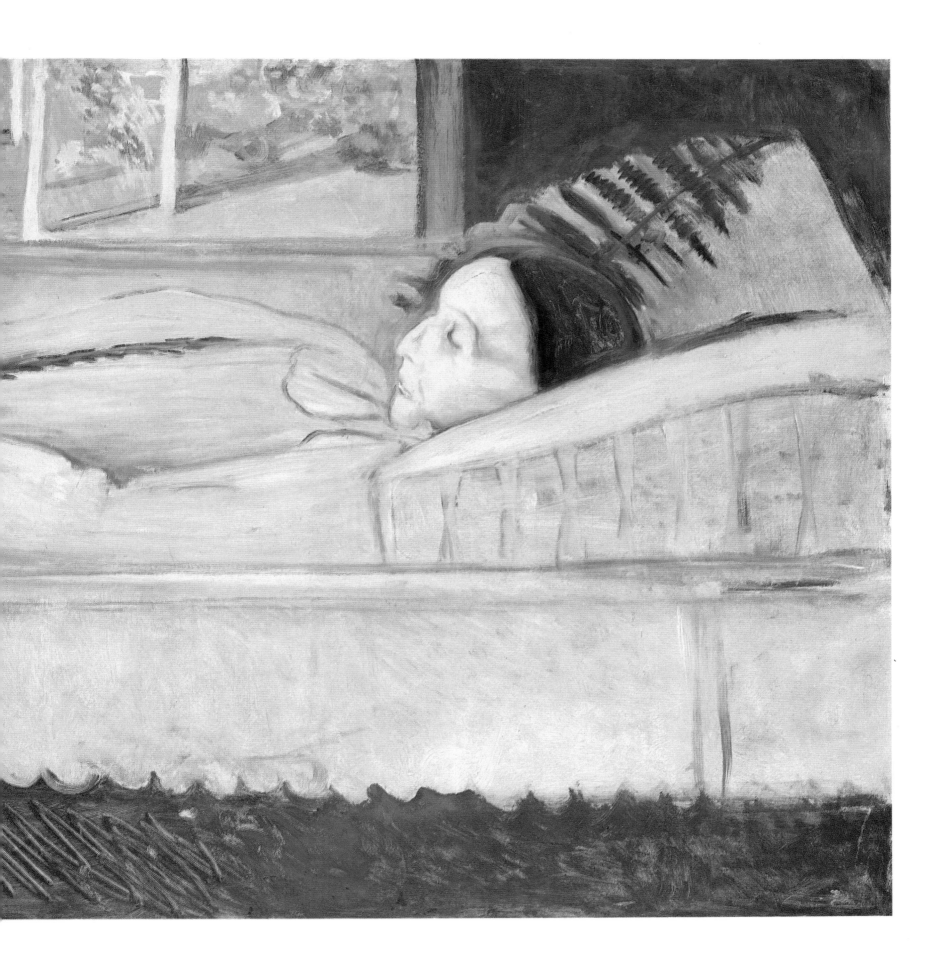

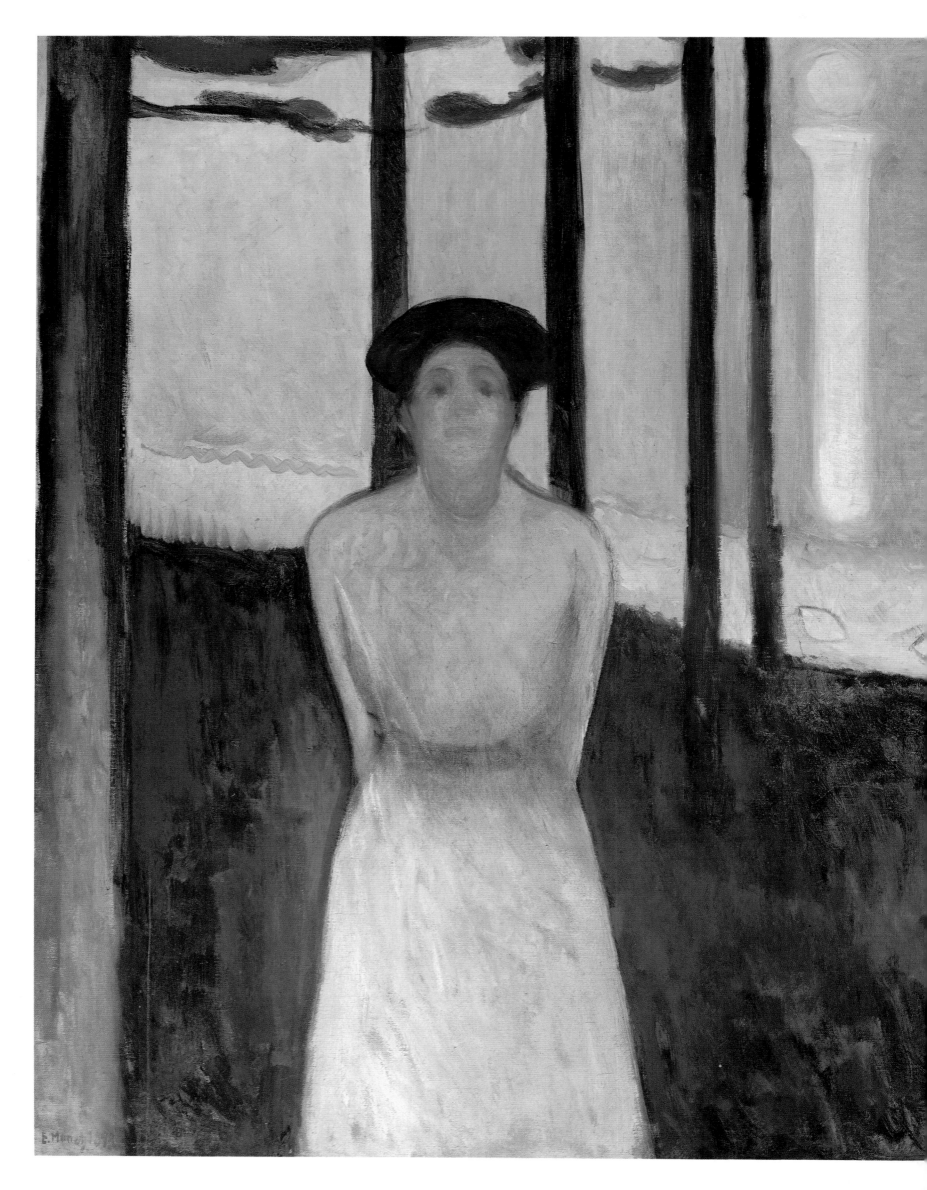

Summer Night's Dream (The Voice), 1893

Oil on canvas
34½×42½ inches (87.5×108 cm)
Museum of Fine Arts, Boston
Ernest Wadsworth Longfellow Fund

Of course the 'voice' is probably an inner voice, the silent mating call of an aroused virgin. Munch appears to have thought of the sun, the moon and the sea as masculine forces which stamped the female earth with its seasonal cycle of fertility and death. The girl leans forward, her face raised, as though offering herself. But her hands are concealed behind her back; she refuses total surrender. Her verticality is supported and amplified by that of the trees; all seem to soar upward in a 'gothic' fashion. Like many before him, Munch associated Gothic architecture with tall woodland trees. From the sun a celestial force of generation, in the form of a 'solid' phallic reflection, reaches down across the water to intersect the upward thrust. A small boat, with two figures indicated by spots of black and white, doubtless symbolizes the male-female bond. As the girl's figure is truncated by the bottom of the picture and the tops of the trees by its top, they do not seem earth-bound. No horizon line limits the girl's aspiration or separates the sun from the sea; the bar of light merely spreads out to indicate the horizon, like a column with a capital at its top.

Using either the sun or the moon – sometimes it is difficult to tell which is intended – Munch included this form in many of his symbolic erotic paintings and prints. He himself once described it as 'the moon's golden pillar.' He may have derived the idea of the 'solid' reflection on water from Theodor Kittelsen, the Norwegian landscape and fairy-tale artist, who used it as early as 1888, before Munch. In a book of humorous drawings published in 1894, reproducing watercolors of 1893, Kittelsen, whom Munch knew and liked, included *Morbid Love* (page 17), the title of a recently banned book by Jaeger. Even if he had already seen *The Voice* or a study for it, Kittelsen's drawing seems like a prophetic parody of some of Munch's subsequent erotic productions.

Dagny Przybyszewska, 1893

Oil on canvas
58½×39⅙ inches (148.5×99.5 cm)
Munch Museum, Oslo

Dagny Juel (1867–1901) was the daughter of a Norwegian doctor, a friend of Munch's father. She came to Berlin as a music student early in 1893 and later that year married Przybyszewski (page 8), the mystical Polish writer who was a central figure in the Schwarze Ferkel circle of bohemians. She was an exceptional allurer of men and a believer in free love, but it is not certain to what extent she practiced this principle. Certainly many fell in love with her, including Strindberg and probably Munch. Years later when she was murdered at Tiflis (Tbilisi) by a crazed disciple of her husband, Munch wrote an affectionate obituary.

He portrays her as a kind of individualized version of the girl in *The Voice* (page 42), but older, and at once more spiritual and more worldly-wise. The pose is quite similar, with body leaning forward, head raised and hands concealed – not behind her back this time but in a scarcely visible muff (as in her photograph, page 8). Her head tilts coquettishly to one side while she smiles, knowingly, sympathetically and perhaps alcoholically; she is reported to have been a heavy absinthe drinker, though never drunk. The body appears translucent and spiritualized, almost dissolved into the blues and purples of the background, which probably symbolize the death Munch habitually linked with sex. Only the head materializes, sanctified by a halo of faintly drawn concentric rings. For Ducha (soul), as she was nicknamed, was an inspirer as well as a seducer of artists.

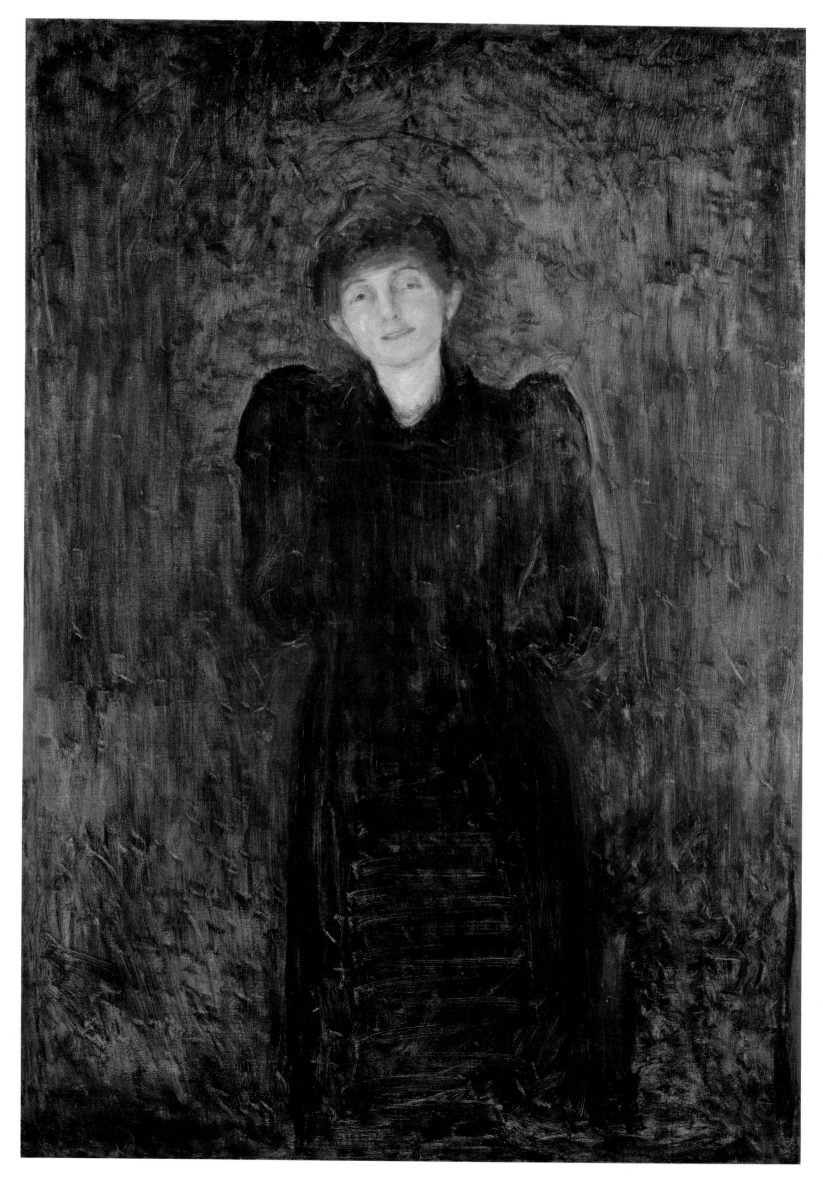

The Scream, 1893

Tempera on panel
32⅞×26 inches (83.5×66 cm)
Munch Museum, Oslo

Essentially this famous picture is autobiographical, an expressionistic construction based on Munch's actual experience of a scream piercing through nature while on a walk, after his two companions, seen in the background, had left him. Fitting the fact that the sound must have been heard at a time when his mind was in an abnormal state, Munch renders it in a style which if pushed to extremes can destroy human integrity. As previously noted, the flowing curves of art nouveau represent a subjective linear fusion imposed upon nature, whereby the multiplicity of particulars is unified into a totality of organic suggestion with feminine overtones. But man is part of nature, and absorption into such a totality liquidates the individual. Beginning at this time Munch included art nouveau elements in many pictures but usually only in a limited or modified way. Here, however, in depicting his own morbid experience, he has let go, and allowed the foreground figure to become distorted by the subjectivized flow of nature; the scream could be interpreted as expressing the agony of the obliteration of human personality by this unifying force. Significantly, although it was Munch himself who underwent the experience depicted,

the protagonist bears no resemblance to him or anyone else. The creature in the foreground has been depersonalized and crushed into sexlessness or, if anything, stamped with a trace of the femininity of the world that has come close to assimilating it.

Several facts indicate Munch was aware of the danger of an art of this sort for a neurotic humanist like himself. He soon abandoned the style and rarely if ever again subjected a foreground figure to this kind of radical and systematic distortion. At the top of another version of the subject (National Gallery, Oslo) he wrote: 'Can only have been painted by a madman.' He certainly had a horror of insanity, which had afflicted his sister Laura. Within the picture, he has set up a defense, in the form of the plunging perspective of the roadway and its fence, which preserves a rational world of three dimensions, holding at bay the swell of art nouveau curves. Safe in this rational world, the two men in the distance remain unequivocably masculine. In the foreground unified nature has come close to crossing the fence, close enough to distort the form and personality of the protagonist. But the fence still protects it from total absorption into subjective madness.

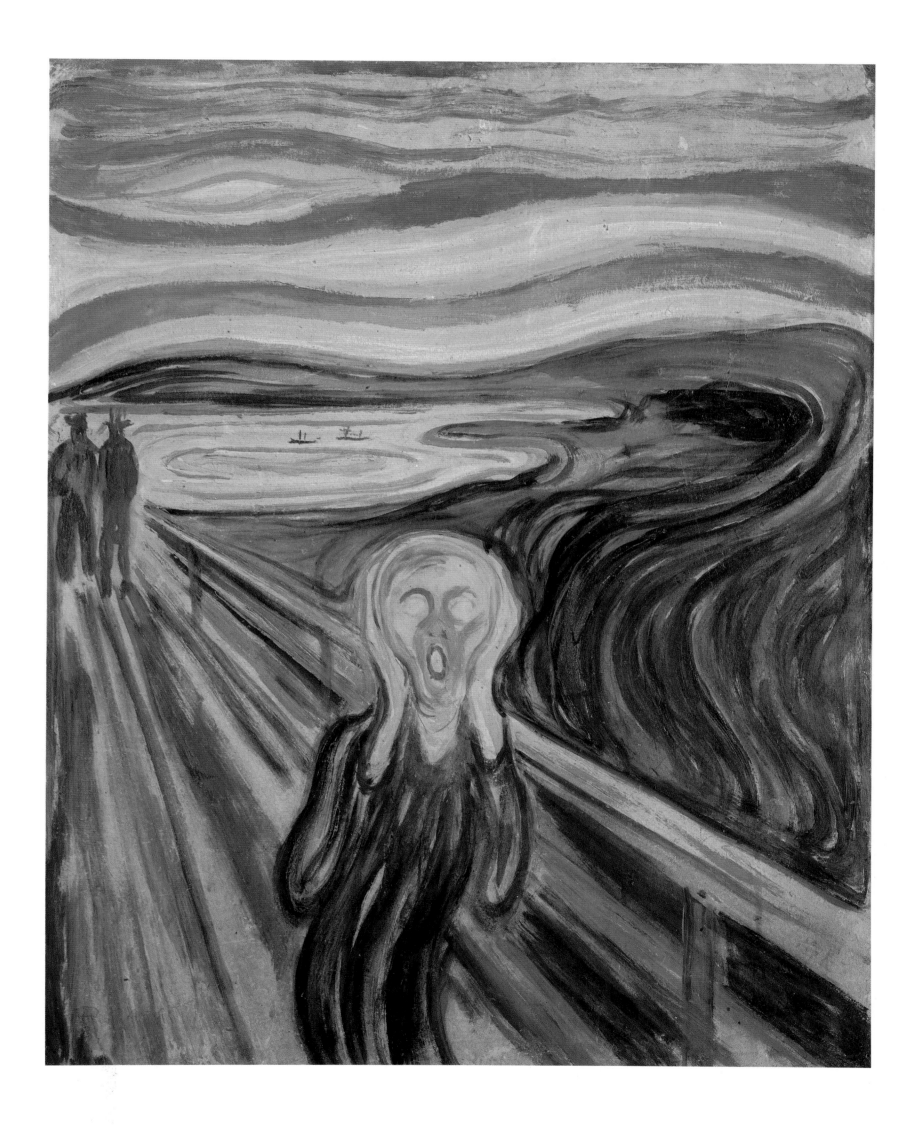

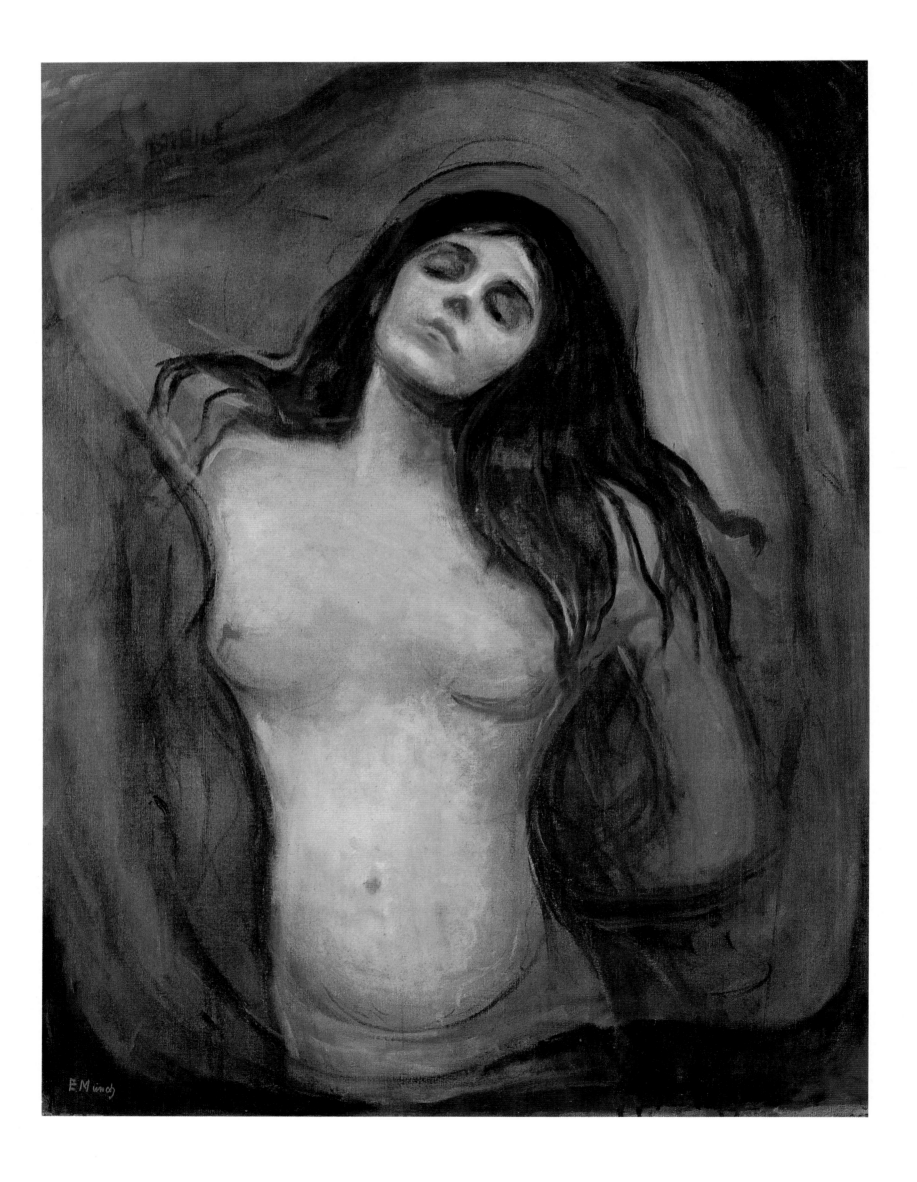

48

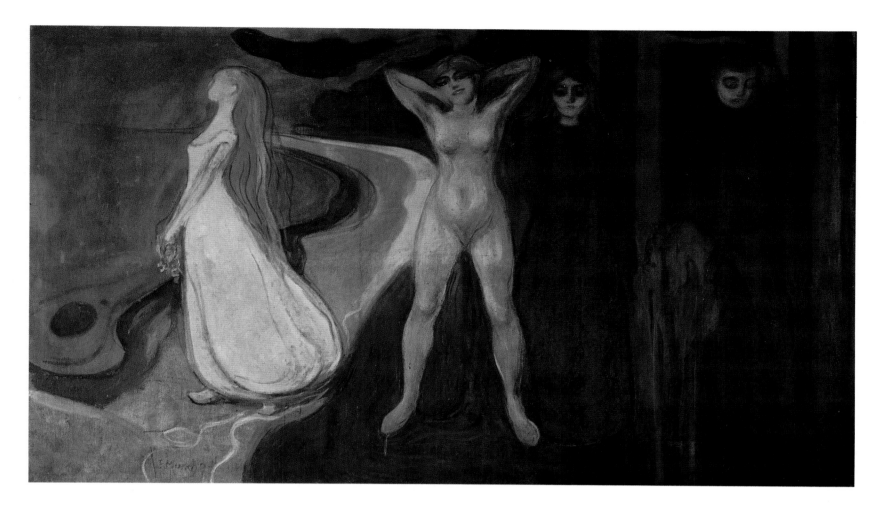

Madonna, 1894-5

Oil on canvas
35⅞×27¾ inches (91×70.5 cm)
National Gallery, Oslo

Originally called *Loving Woman*, this picture can be taken to symbolize what Munch considered the essential acts of the female life cycle: sexual intercourse, causing fertilization, procreation and death. Evidence for the first is in the picture itself, an intensified, spiritualized variation in the nude of the 'mating' pose (cf pages 42 and 45), the woman depicted as though recumbent beneath her lover. The ethereal beauty of her face was said to resemble both Dagny Przybyszewska and her sister Ragnhild Bäckström. Procreation was implied by the decoration of the original frame, later discarded, on which were painted drops of semen and an embryo (retained in a lithograph of the subject, page 18). That Munch associated the image with death is clear from his own comments on the picture, in which he sees it as representing the eternal cyclical process of generation and decay in nature. He continually connected love with death: for the man, because it eviscerated him, for the woman, because, following Schopenhauer, he appears to have thought her function ended with child-bearing.

To call the picture *Madonna* is not inappropriate if the word is understood metaphorically, for Munch, unable to accept Christianity or a personal god, regarded the continuous generation and metamorphosis of life in a religious light,

subsuming its spiritual as well as its material components. The blood-red halo around the woman's head could be considered the spiritual counterpart to the touches of red on her lips, nipples and navel. She seems to float within curving bands of colored light suggestive of art nouveau. Far from deforming her, however, they look like a supernatural emanation, possibly deriving from the spiritualist notion of an aura, surrounding all individuals but only visible to mediums. Munch's friend Strindberg, who dabbled in the occult, was familiar with this idea.

Woman in Three Stages (The Sphinx), c. 1894

Oil on canvas
64½×98½ inches (164×250 cm)
Rasmus Meyer Collection, Bergen

Of many variations on the theme of the phases of womanhood, this picture is the most complete. In the left half stands an adolescent girl, alone in a deep space, facing the sea, the cosmic instrument of her arousal. The motive may derive from a well-known picture of 1864, *Villa by the Sea*, by the Swiss-German romantic painter Arnold Böcklin, whom Munch greatly admired. In Munch's picture both the girl and the shoreline stretching behind her are drawn with sinuous art nouveau curves, suggestively feminine. Munch tended to apply such treatment to

dreams or recollections of the past that have become blurred in the memory and can be fused into flat subjective patterns. In contrast, the right half of the picture, treated more realistically, contains three figures pushed forward by the forest of trees behind them. This kind of opposition is typical of sixteenth-century mannerist painting, with which Munch occasionally shows an affinity. The nude, red-haired woman in the center adopts a mating pose, with hands hidden and legs wide apart; she is not unlike the *Madonna* (page 48) but lacks her spirituality, and her face wears a mocking smile. Next to her is a sad, wan, older woman, doubtless representing the supposed emptiness of post-nubile life, with nothing but death to look forward to. Finally, on the extreme right stands an unhappy man, probably deliberately clumsily drawn, the hapless victim of inevitable erotic distress. Both he and the older woman are dressed in black and both seem imprisoned by the trees enclosing them, whereas the lustful nude in the center stands clear of the forest. The man seems to grope at a plant dripping with blood which Munch later identified as a mandrake. Mandrake (*Alrune*) was the name of a poem by his friend Goldstein, in which the plant, shedding blood, is associated with the sufferings of the love-lorn artist. Munch, whose source this undoubtedly was, may have intended the same meaning. Or he may be referring to one of the many superstitions attached to this poisonous plant, for example that to pull it out by its roots meant madness or death.

Ashes, 1894

Oil on canvas
47½×55½ inches (120.5×141 cm)
National Gallery, Oslo

For sheer beauty this work ranks high in Munch's oeuvre. As a static tableau of the mind, it shows the influence of the French synthetist painters. But its looser contours, sometimes doubled, rich somber colors, and lack of primitivist stylization give it a life and atmosphere rarely found in their work.

When lovers are consumed by the hot flame of passion their love turns to ashes. That clearly is the meaning indicated by the title. The elements comprising the scene, however, suggest a more ambiguous and complicated content. Sexual activity over, the lovers have separated. The man, in averted profile, cowers in grief or fear while the woman stands erect and faces the front, her white dress not yet buttoned up to conceal her sensual red undergarment. She fixes her hair, whose flowing tresses still rest on the man, forming the contour of his head and shoulders and showing that she still dominates him. Most mysterious is the horizontal form at the bottom combined with the vertical border on the left with its undulating, perhaps flame-like, lines. These elements may be intended as a symbolic border such as Munch used in the *Madonna* and *Self-Portrait* lithographs (pages 18 and 9). About another picture he wrote of 'the forest which sucks its nourishment from the dead.' If this be accepted as a clue, what this border represents, following Munch's way of thinking, is a stream of sperm sucked up by a tree, the next beneficiary of death following love in the cyclical process of biological immortality. The man buries his anguish in the corner between the stream and the tree, framed by its vertical and that of the woman, to whom the hair links him. The tall trees in the forest behind also show markings that might suggest drops of liquid.

It might be noted that nothing obviously resembling ashes can be seen. In the title Munch refers to a metaphor but, except possibly in the flame-like tree, ignores it in the picture, instead using a more direct symbolism for a more comprehensive idea.

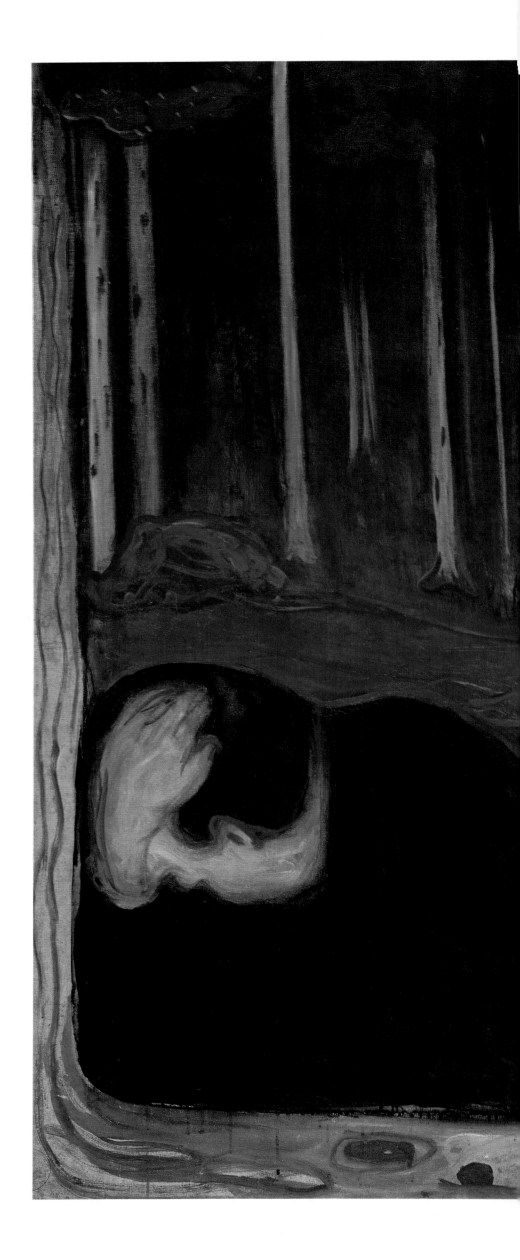

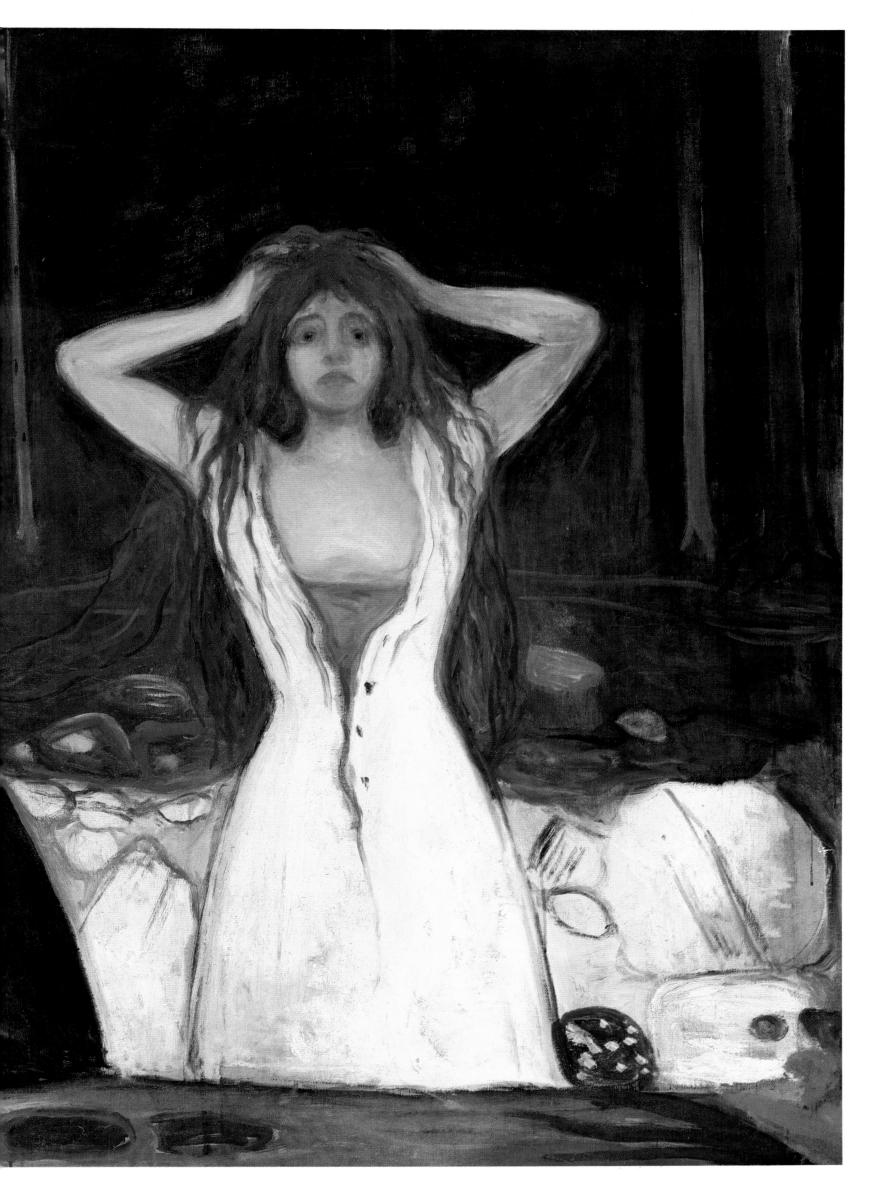

Melancholy, 1894-95

Oil on canvas
31⅞×39⅜ inches (81×100 cm)
Rasmus Meyer Collection, Bergen

The practice of free love by the bohemians of Christiania, advocated by Jaeger as suited to an anarchist society, led to a good deal of jealousy. Among those who aroused it was Oda Krohg (wife of the painter Christian Krohg), who became, to borrow Tom Lehrer's phraseology, the hypotenuse of a triangle involving her husband and Jappe Nilssen, a young journalist who was a friend of Munch. His jealousy inspired this symbolic composition which Munch painted in several versions under various titles: *Jealousy, Jappe on the Beach, Evening, The Yellow Boat,* and *Melancholy.*

Nilssen sits miserably among the rocks on the shore at Åsgårdstrand, in the profile position of contemplation, much in the manner of Inger Munch in *Inger on the Beach* (page 29). In the distance the figures of a man and a woman, Christian and Oda Krohg, are about to embark on a boat, bound for an island where they will make love. Nilssen is painted in the manner of the Pont-Aven school, in heavy inflexible contours. They further flatten a figure already flattened by the profile silhouette, and do not altogether harmonize with the vague plastic implication of the face and the hand supporting it. The distant view is fused into art nouveau undulations. We are in fact presented with two different images: firstly, an imaginary but objective view of a melancholy man and secondly, a blurred picture of the distant scene his mind's eye conjures up as a metaphor of the cause of his melancholy. Such double images, demanding a transfer from our own eyes to the mind's eye of a foreground figure, are not uncommon in Munch.

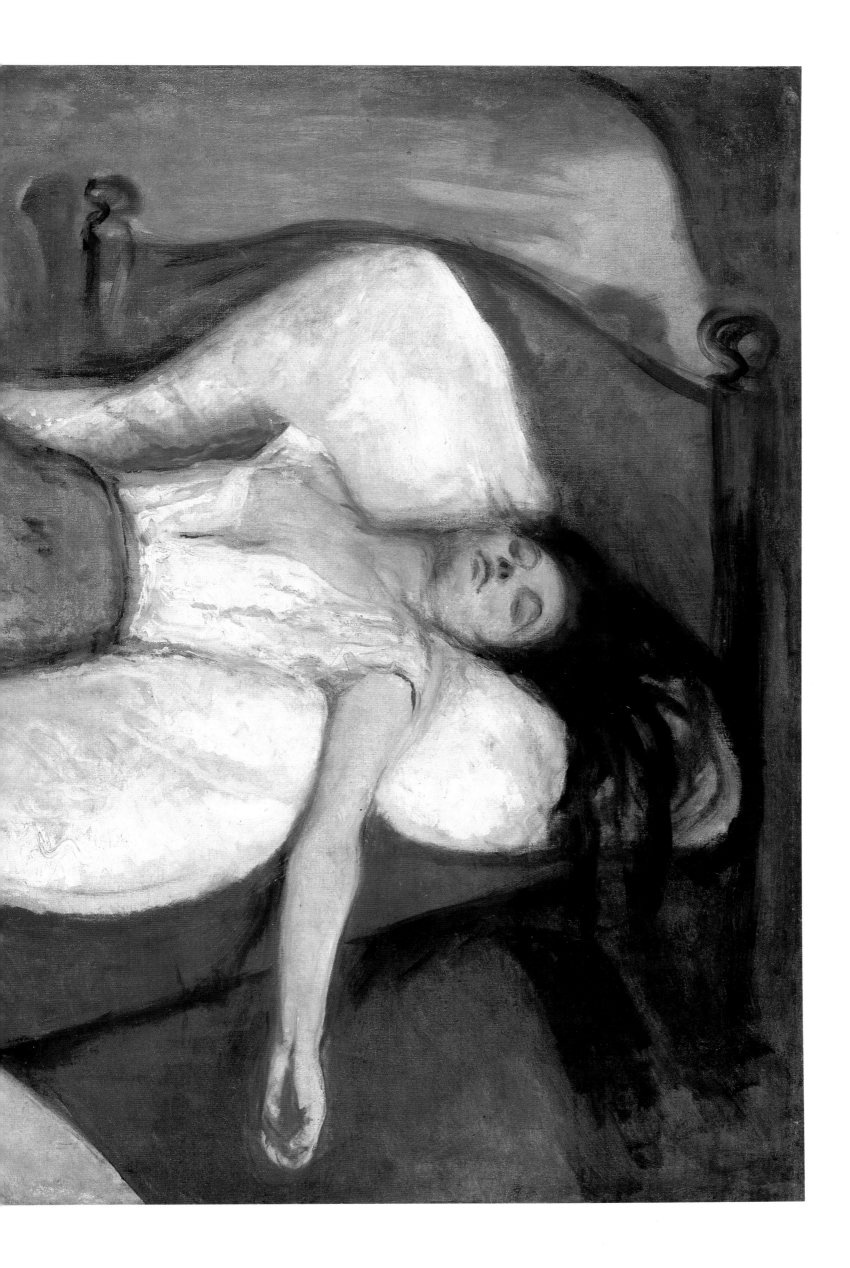

Previous pages:
The Day After, 1894-85

Oil on canvas
45¼×59⅞ inches (115×152 cm)
National Gallery, Oslo

When Jens Thiis bought this picture for the National Gallery, Oslo, in 1909 the public was shocked; one critic denounced it as portraying a drunken prostitute. This is unlikely to have been Munch's idea. He did paint several pictures of prostitutes, tending to depict them as unattractive or even grotesque, whereas this woman closely resembles the *Madonna* (page 48) and, different though the setting, shares her ethereal beauty. She is probably intended to illustrate one aspect of the essence of protean womanhood portrayed in that work. Both paintings in fact relate to a lost picture by Munch that Hans Jaeger had with him in his prison cell when jailed in 1886 for publishing *From Christiania's Bohemia,* a novel in which descriptions of free bohemian life parallel what is shown here. The present picture is more directly a replica, modified by his style of the 1890s, of the same subject painted in 1885-86 and also lost. One important Norwegian precedent for the depiction of a dissolute woman would undoubtedly have been known to Munch, Hans Heyerdahl's tiny, exquisite painting of *The Champagne Girl* (page 12), which was also strongly attacked when exhibited. If Munch's picture represents 'The Day After,' Heyerdahl's might be called 'The Evening Before.'

Until his late years Munch never showed any interest in still-life painting for its own sake, but he sometimes introduced it into subject pictures, giving it, as in this case, the status of a separate image, a material correlate of the human situation portrayed. Gauguin had employed still life in a similar manner in some of his portraits, without giving it the same degree of independence. In *The Day After* the differing pairs of bottles and glasses hint that the woman has had a nocturnal visitor.

Self-Portrait with Cigarette, 1895

Oil on canvas
43½×33⅝ inches (110.5×85.5 cm)
National Gallery, Oslo

Apart from Rembrandt, few artists have produced self-portraits to equal this in psychological intensity. In some respects it harks back to the major works of ten years before, like *The Sick Child*, with its dense atmosphere impulsively rendered by streaky scumbling and drippings of paint. The mystery of this atmosphere is heightened by unusual lighting from the lower right, which throws the face into unfamiliar relief and creates an ominous shadow behind, mingling with multiple contours and blue smoke from the cigarette. Yet through all this murky atmosphere the face and hand emerge brilliantly lit, revealing a startled alertness in the eyes, echoed by the turn of the head and the exaggerated projection of the ear, cocked to catch an unexpected sound; it is as though Munch has been seized by sudden fright, whether caused by an external agency or, more probably, some thought crossing his mind. The blue and brownish purple color scheme could carry the connotation of death.

Munch had previously used tobacco smoke for psychological purposes in a work of the mid-1880s, but the picture with which this self-portrait challenges comparison and which he probably had in mind is Christian Krohg's striking portrait of the artist *Gerhard Munthe* (page 12). With his elegant overcoat, cultivated moustache and relaxed posture, he looks the sophisticated dandy, at ease in any social situation. Smoke from his cigar drifts into the smoke-filled atmosphere of the Grand Café, a favorite haunt of the bohemians, linking him to that milieu, though he is ready to depart for another. Munch uses the smoke device in exactly the opposite way, not to relate the figure to an environment but to isolate it. Instead of external social deportment, Munch depicts internal stress and anxiety.

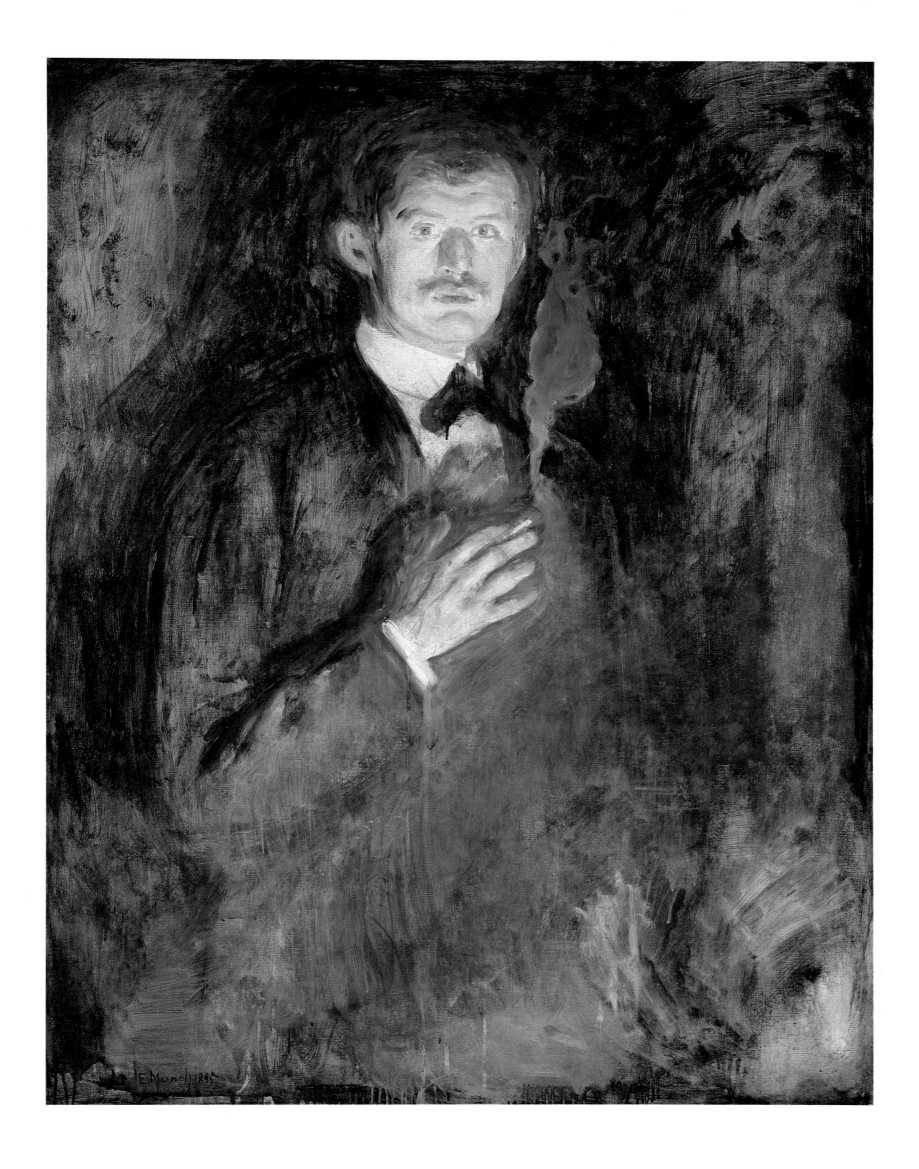

Death in the Sickroom, 1895

Oil on canvas
59×66 inches (150×167.5 cm)
National Gallery, Oslo

Reverting to the theme of the death of Sophie, Munch produced a work very different from *The Sick Child* (page 24). Now the whole family is shown, and the emphasis shifts from the experience of the dying girl to that of the mourning relatives. The child sits facing diagonally to the rear, largely invisible both to us and to all the mourners except her praying father; she is already absent from their lives. What we do see of her is partly transparent, as though she were already beginning to dematerialize. Each of the mourners reacts differently and there is no intercourse among them; confronted with the loneliness of death, each retreats into his or her lonely self. The younger sister Laura, in the extreme foreground, is the only other figure seated, in a profile pose of sorrowful meditation. Possibly her position echoing that of her sister indicates that she too was destined to suffer at an early age from an incurable illness, though mental instead of physical. Or

perhaps the whole scene behind her pictures her distorted memory of the terrifying event. The painting is very much in Munch's version of the synthetist style – flattened areas enclosed by strong contours. The receding floorboards converge towards different vanishing points approximately on a horizontal axis, thus flouting naturalistic perspective. This has the effect of both flattening and widening the room.

Dissimilar though it is in style, Heyerdahl's big painting of 1882, *The Dying Child* (page 7), based on memory of the loss of a younger brother, was clearly the pictorial source for Munch's composition. Here too the room contains six mourners, and as in Munch's picture the emphasis is on them rather than on the dying child. Inger Munch's pose, facing the spectator, away from the tragic event, resembles that of Heyerdahl's distressed mother. Both artists painted varying versions of their scenes.

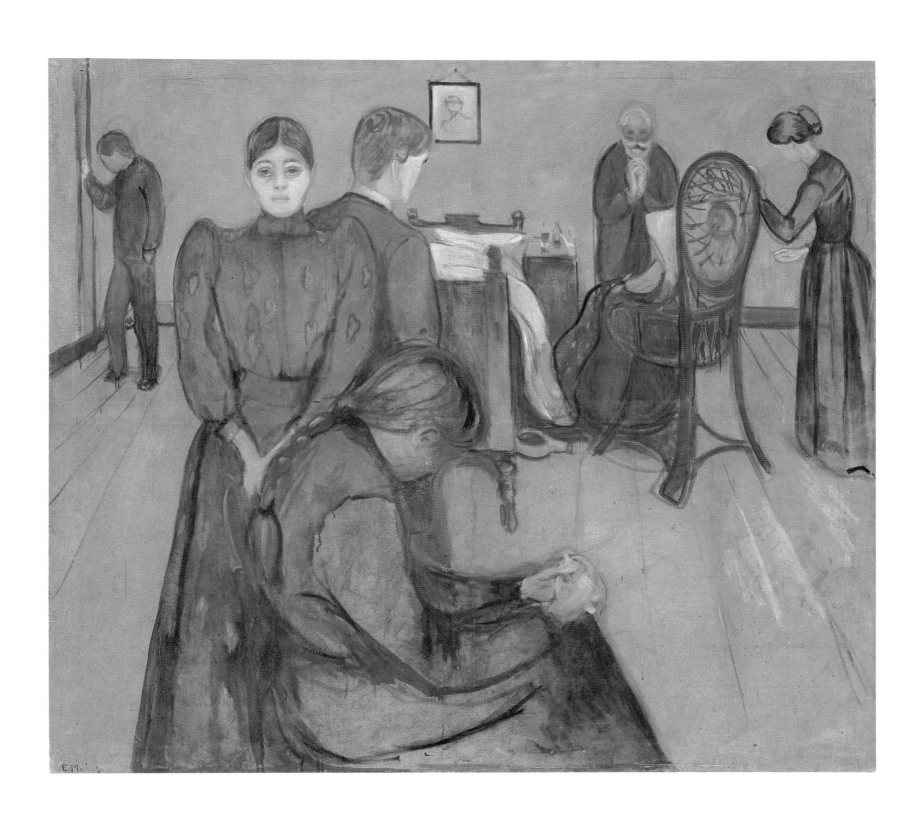

Separation, c. 1896

Oil on canvas
38×50 inches (96.5×127 cm)
Munch Museum, Oslo

Over and over again in his pictures of the middle 1890s Munch used variations of the same images – the column of light on the sea, the blonde girl on the beach, the lustful woman in red, the older woman in black, the unhappy man, etc – juggling them in various combinations to symbolize different human conditions and relations. Here he illustrates the man's sorrow at parting from his love – the end of the story begun in *Attraction* (page 17). As in other cases, the picture consists of two components, the objective in the foreground, in which the protagonist may be either frontal and active, as here, or in profile and contemplative, and the subjective in the background, the image of the past in his or her mind's eye. The lovelorn man appears about to move forward, into the future, but his path is blocked by the crimson plant, again possibly intended as a mandrake, with its love and death symbolism. He seems trapped in the present. Moreover the girl's long hair floats across into his world and caresses his head, tying him to his vision, allowing him no escape from his memory. By means of linear fusion the girl's flowing curves are assimilated into the flat, art nouveau pattern of the shoreline, creating a unified and feminized vision of the past. The man's figure, on the other hand, with its black silhouette and more circumstantial contours, unites with the bloody plant to form a more articulated pattern.

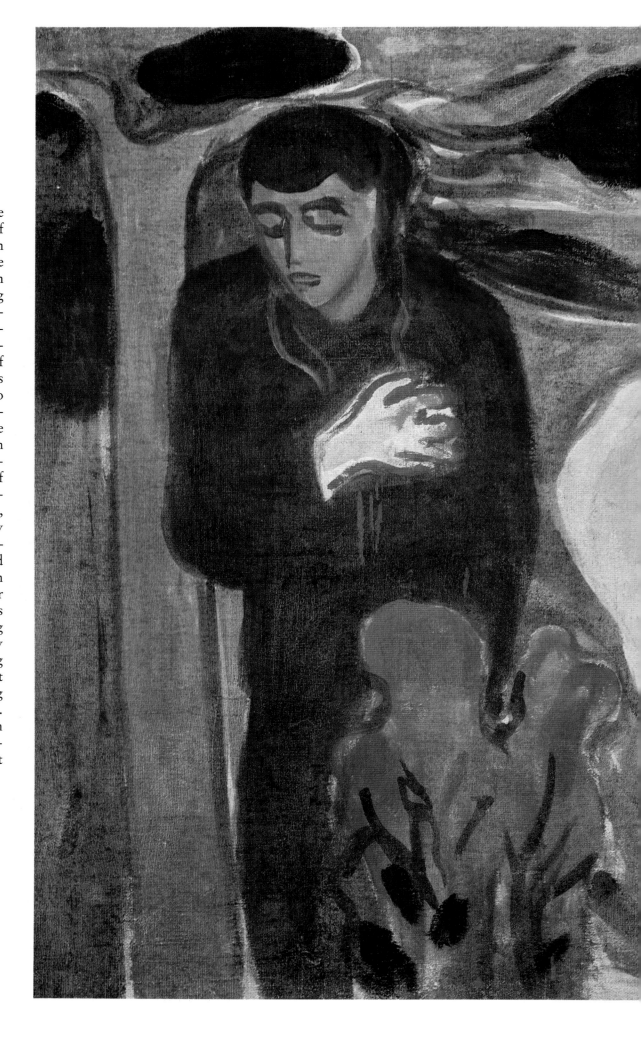

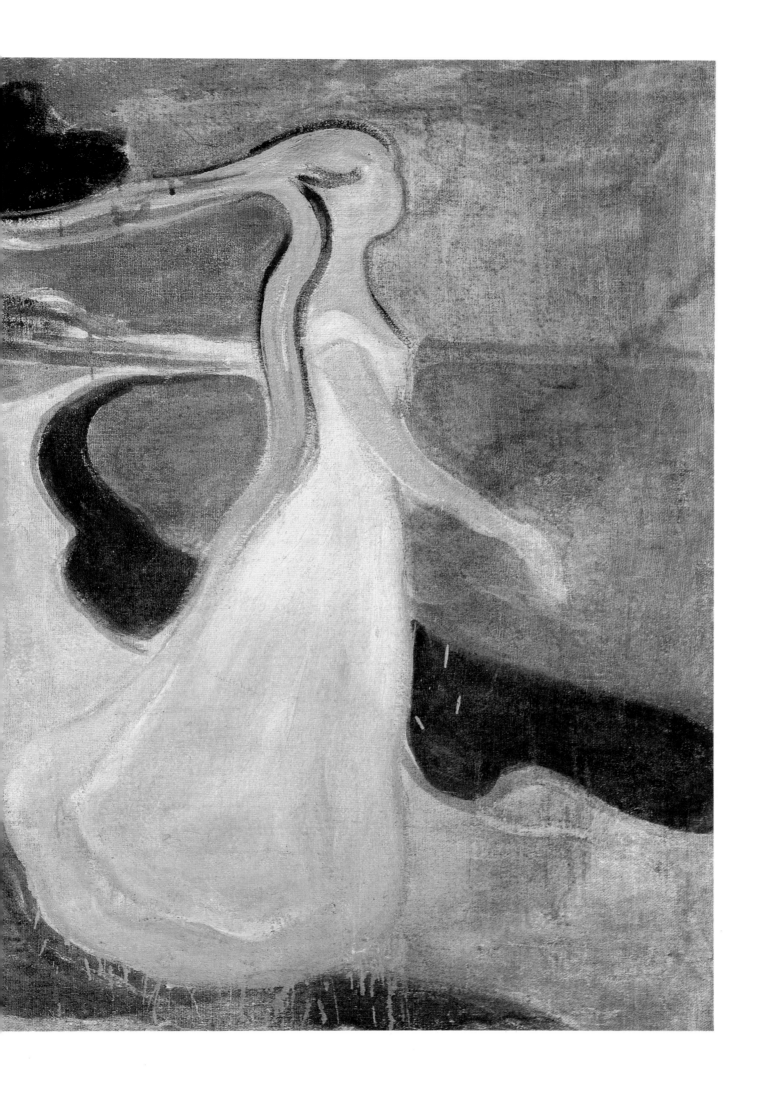

Red Virginia Creeper, 1898-1900
Oil on canvas
47×47⅝ inches (119.5×121 cm)
Munch Museum, Oslo

By the end of the century some paintings had begun to show signs of a disintegration of Munch's synthetist art nouveau style. This is a good example. Colors have brightened but the pattern is weakened in places by insufficient value contrast and by indiscriminate mingling of positive and negative lines and of flat and modulated areas of color. Nevertheless it is a powerful conception, the very confusion increasing the disturbing effect. The man strives to escape his frightening vision. His head decapitated by the base line suggests death, matching the barren tree with

the stump of a severed branch and the strangulation of the house by a bloody parasite. With red eyes and fearful greenish face he appears to flee along the winding road toward us, away from whatever menace the house holds for him. As in *The Storm* (page 39), this house is anthropomorphized by a central nose-like element between multiple eyes.

It has been suggested that the scene represents jealousy. Some features do resemble the picture of that name (page 54): the truncated forward-facing figure darkly clad, with features vaguely like

Przybyszewski's, and the blood-red in the background. Here is an admittedly fanciful explanation, offered with the excuse that Munch's pictures continually invite speculative interpretations. At the time he painted this picture Munch was having his affair with Tulla Larsen but dreaded the entanglement of marriage (jealousy of her other lovers may have been one of the reasons). The plant encircling the house is a virginia creeper. This is not a wine grape but a member of the same vine family. Tulla's father was a wealthy wine merchant.

Fertility, 1898
Oil on canvas
47¼×55⅛ inches (120×140 cm)
Private Collection

Here Munch employs a traditional Adam and Eve composition to create a beautifully balanced symbolic image. All the elements combine to form a static flat pattern simplified with qualified art nouveau linearity and undisturbed by foreshortening. The figures are placed in contemplative profile, with the woman's head gently crowned by a tree branch and the man's hat linked to the curves of the distant hills, and in reverse to the basket held by the woman.

Munch gives a highly personal twist to the idea of fertility. Again, the work was painted at the time when he was exposed to the matrimonial blandishments of Tulla Larsen, and he makes it clear that to marry and be fertile would for him have disastrous consequences. The tree laden with fruit, the basket of cherries, the pregnancy of the woman, the field of vegetables, all point to the benefits of fertility, the continuance of life. But the man sits hunched and forlorn, his hollowed guts

transferred, as it were, to the swollen belly of the woman. He looks as though he could hardly walk without the aid of the stick at his side. Confronting him is the stump of a sawn-off branch, for Munch probably signifying impotence in what he valued most, his ability to produce great art. From his standpoint, fertility meant sterility. The darkened eye of the woman hints that her fate is also sealed, that only death will follow the completion of her generative mission.

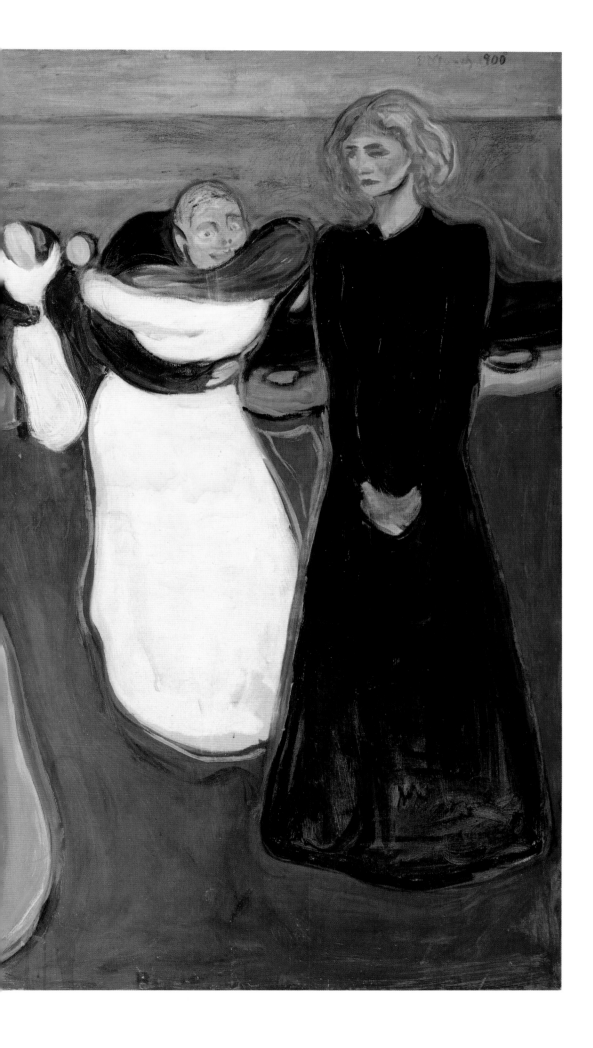

The Dance of Life, 1899-1900

Oil on canvas
49⅜×75 inches (125.5×190.5 cm)
National Gallery, Oslo

A distinction can be drawn between those of Munch's imaginative works that are directly symbolic, like *Jealousy* or *Fertility*, and those like the present picture that are illustrations of a metaphor. The latter may be more difficult to interpret. Life is not in fact a dance and the metaphor is too vague to give much indication of what is intended. The picture, however, appears to be a more complex and personalized version of *Woman in Three Stages* (page 49), with an innocent woman in white on the left, a sensual woman dancing with the man, and an anguished woman in black on the right. All three resemble Tulla Larsen; the girls dancing in the background may also represent her. The man in the foreground appears to be Munch.

It is possible to construct a reasonable explanation of the scene if we remember that at times Munch used the depth of the picture space as a time scale, moving from the distant past in the far background up to the present in the foreground adjacent to the picture plane. Applying this principle here, the initial impulse for life's dance comes from the sun with its phallic column of light crossing the sea. In front of this, far away on the beach stands a solitary girl, waiting for a sex partner. At about the same distance but now on the greensward a group of men appear to contend for the girl's favors – a point where jealousy arises. Nearer to us a chosen male partner dances decorously with the girl; this is the stage of courtship. Still closer to the foreground courtship has progressed to lust, in the form of a leering man ready to ravish his partner. His face is a gross caricature of the playwright Gunnar Heiberg, who had introduced Munch to Tulla Larsen and of whom he was jealous, believing Tulla had previously had an affair with him. The girl still wears white but her hair has darkened and reddened. The couple in the foreground represent the final stage, where the dance of life turns into a dance of death. They glide through the motions like somnambulists, trapped by their fate. Munch's feet are enveloped by the coils of Tulla's red gown, while its predatory contour almost completely encases him. Yet there is no eye contact, they remain spiritually remote from each other. Placed in profile, unlike nearly all the other figures, they form the timeless image of a pair for whom creative life, his artistic, hers biological, has ended. Tulla on the left looks forward naively to connubial bliss, for her gaze misses the distressing vision, but she on the right looks straight at it, apprehending the fatal consequences of love.

Girls on the Pier, 1901

Oil on canvas
23½×49⅜ inches (136×125.5 cm)
National Gallery, Oslo

On the jetty at Åsgårdstrand three girls gaze into the water at the reflection of the distant shore. It was a theme Munch repeated many times with variations. Together with its reflection the big tree (or mass of trees) acquires a vaguely phallic shape, giving rise to the idea that the subject alludes to the onset of puberty. That may be the case, but it is also probable that the water is intended to reflect a memory of early childhood. The deep recession in perspective may signify look-ing back with the memory's eye along a stretch of time. The railing against which the girls lean lacks any supporting posts, giving it unbroken continuity. Then comes the vanishing point of its perspective, an abrupt end separating it from the background which, contrary to the three-dimensional reality of the jetty, is reduced to a flat, somewhat art nouveau, pattern. The continuity of the fence may be taken to symbolize continuous memory, ending at a point in childhood beyond which only detached memory images can be recalled. The reflection in the water seems to reflect such a dim image of the past floating in the minds of the girls, who are placed in transverse poses of dreamy contemplation. Discrepancies between the background and its reflection may point to the inaccuracy of memory: in the reflection the house on the left is of a different shape, with three windows instead of two and no chimney, while the moon has disappeared altogether.

Dance on the Shore, 1900-02

Oil on canvas
39×37¾ inches (99×96 cm)
National Gallery, Prague

For the sheer beauty of its color pattern and a rhythmically flowing design of almost Chinese elegance Munch rarely equaled this picture. In addition it creates a strange romantic mood of the interaction of humanity and nature tinged with hints of perversion. It is an unusually pure art nouveau conception, in calligraphic lines and strands of color, with hardly any indication of depth beyond recognizable changes of scale. The sun's light crosses the sea without the harsh intervention of a horizon line, which would have created distance and disturbed the delicate curvilinear pattern. As

the column of reflection approaches the shore the ripples in the water split it into separate images, like drops of heavenly semen about to enter the cavity in the undulating feminized seashore. Nearby two girls dance together, framed by the graceful tree branch, the one the familiar virginal blonde in white, the other a yellow-clad, red-haired sensualist, who tries to drag her reluctant partner into the ambit of the sun (for lesbian purposes?). Glimpsed between the two main branches of the tree on the right are two hooded older women, perhaps the mothers of the dancers. On the extreme right a woman in

bright red reclines in sorrow, doubtless expressing the aftermath of sexual gratification – or frustration.

No obvious man is present to disturb this female domain, but a note of foreboding is struck by the weird creature beneath the gap in the shore, seemingly partly covered by what looks like a sheet of paper. Possibly this is a harbinger of the perversions of nature resulting from misalliance that Munch later described in the story *Alpha and Omega* which he wrote and illustrated in 1909 while under treatment for alcoholism in Dr Jacobson's clinic.

White Night, 1901

Oil on canvas
45½×43½ inches (115.5×110.5 cm)
National Gallery, Oslo

While staying at Ljan, on the east side of the fjord south of Oslo, Munch painted a number of landscapes of which this is a typical example. Though employed to very different effect, the style resembles the flat, flowing art nouveau simplification of *Dance on the Shore* (page 69). By choosing a downward line of sight from a high eye level on sloping ground Munch is able to look over the tops of the trees and show a great expanse of the frozen fjord beyond. The saw-tooth contour of the spruce forest in the middle ground suggests the hardness and thickness of the ice; in the dead of winter the sea cannot serve as a medium for a vitalizing solar force, and the landscape is lit by an unseen moon on the left behind the spectator. The little house in the forest has no windows. At the bottom left lies a dead log of wood presenting a cut face coated with snow, symbolically related to cut tree-stumps in other works (e.g. pages 54 and 65). Yet life is not extinct. The idiomatic contours of the pines and spruces in the foreground make these trees into individuals, their loosened, multiplied contours give them the elasticity of living beings, and where there are gaps in the foliage the spots of snow and ice seen through them look like the eyes of strange faces. Like Palmer and Van Gogh, Munch at times seems to endow his landscapes with animistic qualities.

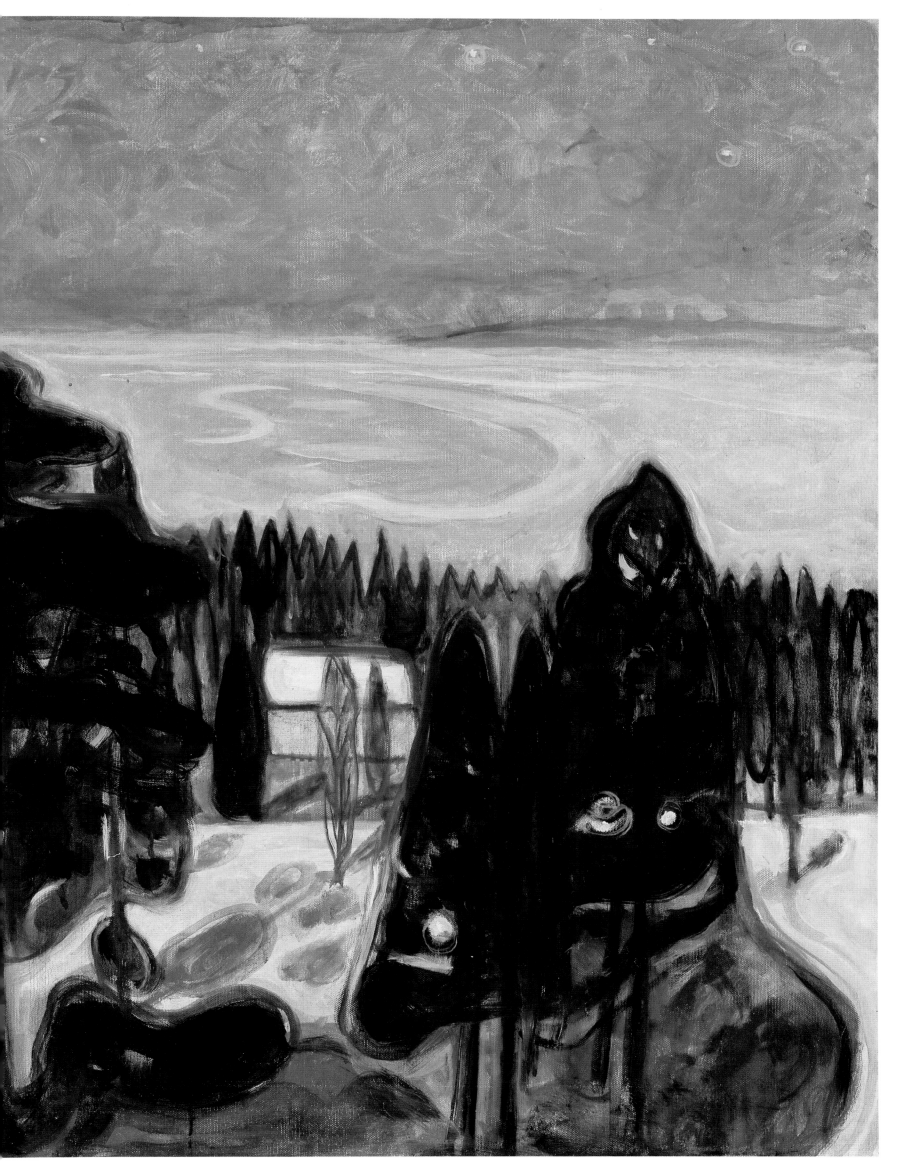

The Fisherman, 1902

Oil on canvas
33⅞×24 inches (86×61 cm)
Munch Museum, Oslo

This picture, approximately coinciding in date with the Tulla Larsen debacle, marks the beginning of new directions in Munch's art. The man presents himself as a static, archetypal image; frontal, and placed against a continuous green background that abstracts him from any realistic environment. He stands firmly – on nothing. Only the shadow he casts contradicts this abstraction, but since it is confined within the angle of his legs it is wholly subordinate to him, not a menacing apparition in exterior space. The impression is of an aggressive masculinity, the opposite of the many representations of male weakness and female dominance Munch had produced in the past. From now on this new masculinity was to become an abiding element in his art. One need only compare *Fertility* (page 65) with *Adam and Eve* (page 19) to see the change that has taken place.

Closely associated with the assertion of masculinity is the assertion of the working class. Munch's left-wing views, early influenced by Jaeger and Krohg, had remained dormant for many years while he was preoccupied with psychological probing. Now they begin to reappear in increasingly numerous depictions of working-class men (seldom women). This fisherman is a proletarian. He stands at ease but ready for physical action, his head and shoulders thrust forward, his legs wide apart with the weight of the body divided evenly between them. Very different is the traditional upper-class relaxed posture, of classical origin, in which most of the weight is placed on one leg while the other serves chiefly to maintain balance; a pose that confers grace and ease but hinders physical activity.

Another feature to emerge here is Munch's liking for Gothic architecture, which he did not advocate for modern revival but associated with heavenly aspiration, tree-tops in woods, and the lives of simple people. The fisherman's silhouette is shaped like a tall Gothic arch, seconded by his dark shadow and the gap between his thighs.

Following pages:

Bathing Boys, 1904

Oil on canvas
76⅜×114⅙ inches (194×290 cm)
Munch Museum, Oslo

Around the turn of the century Munch painted several pictures of bathers, both male and female. In the present example he divides the picture space roughly into two zones, a foreground consisting of the beach, in which the figures are treated fairly realistically, and a background of bathers in the sea, reduced to a fluid art nouveau memory image in a completely different perspective. The youth in the foreground adopts a masculine swagger as if to assert his maturity. Behind him two boys appear to engage in homosexual play. As they become more distant, those in the sea are increasingly fused by the art nouveau pattern into simplified curvilinear shapes suggestive of embryos or primitive organisms. For the parts of their bodies under water this is not altogether implausible, as the refraction and rippling of the surface would normally cause some distortion. But Munch distorts the whole figure, the parts above the water surface as much as those below. Near the shore the figures become somewhat more mature and realistic. What results is a suggestion that the background represents a dim memory of the biological evolution of the past, distance in space again signifying distance in time. If that is the case it is possible the evolution portrayed may be intended to be that of humanity as a species as well as of individual man. Munch may have been aware of the well-known recapitulation theory of the German biologist and philosopher Ernst Haeckel (1834–1919), who maintained that the embryological development of the individual repeats the evolution of the species.

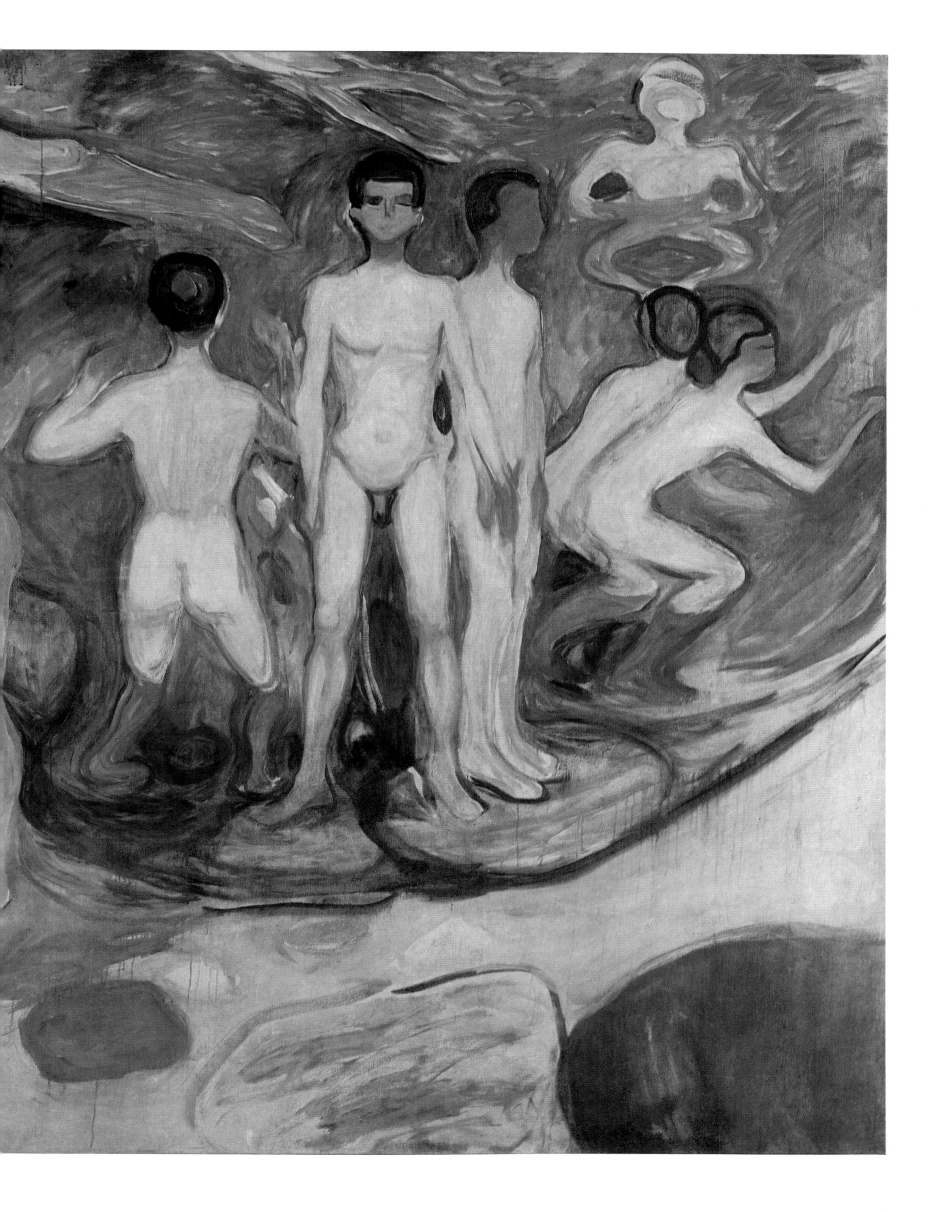

Family on the Road, 1902-03

Oil on canvas
77½×48 inches (197×122 cm)
Thielska Gallery, Stockholm

The association of distance in space with
distance in time takes many different
forms in Munch's art. Whereas in the pre-
vious plate the emphasis is on regression
into the past, here it is upon progression
into the future. The road may be under-
stood as a symbol of time. From rear to
front we are shown three successive gen-
erations of a family, while the doll held by
the child points to a fourth to come. All
but the first face the front, ready to move
into the future, but the grandmother has
turned aside, assuming a transverse posi-
tion of timeless meditation. She can pro-
gress no further along the road of life and
only meditate on a blurred picture of the
past, the glimpse of distant roadway and
landscape fused into a flowing subjective
pattern. The nearer landscape on the left,
on the other hand, is painted in a more
articulated fashion. Since the little girl's
hat resembles a halo it would seem she
and her doll are cast in the roles of
Madonna and Child, an association of re-
ligion with generation Munch had pre-
viously made in his *Madonna* (pages 18
and 48). Conspicuous by their absence are
the two necessarily male members of the
family; clearly Munch looked upon pro-
creation as an essentially female function.

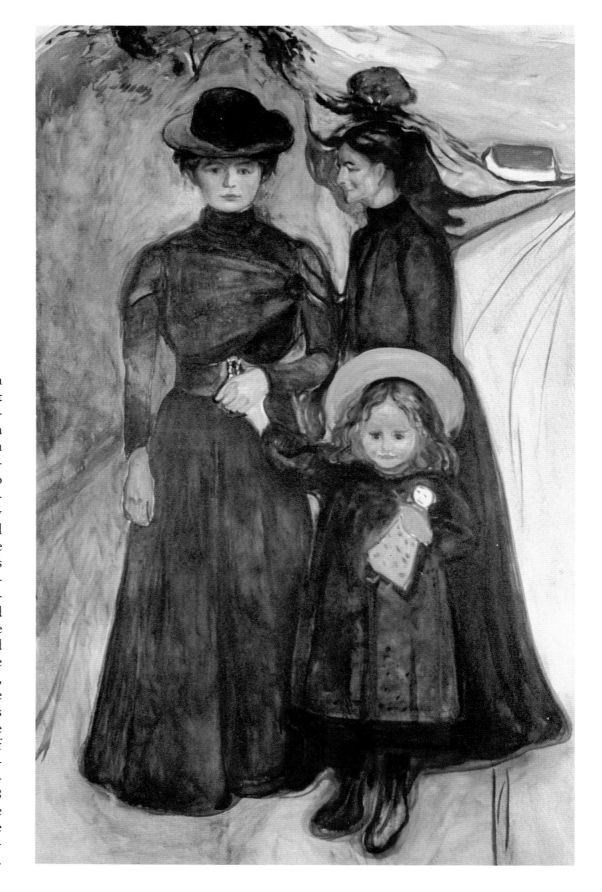

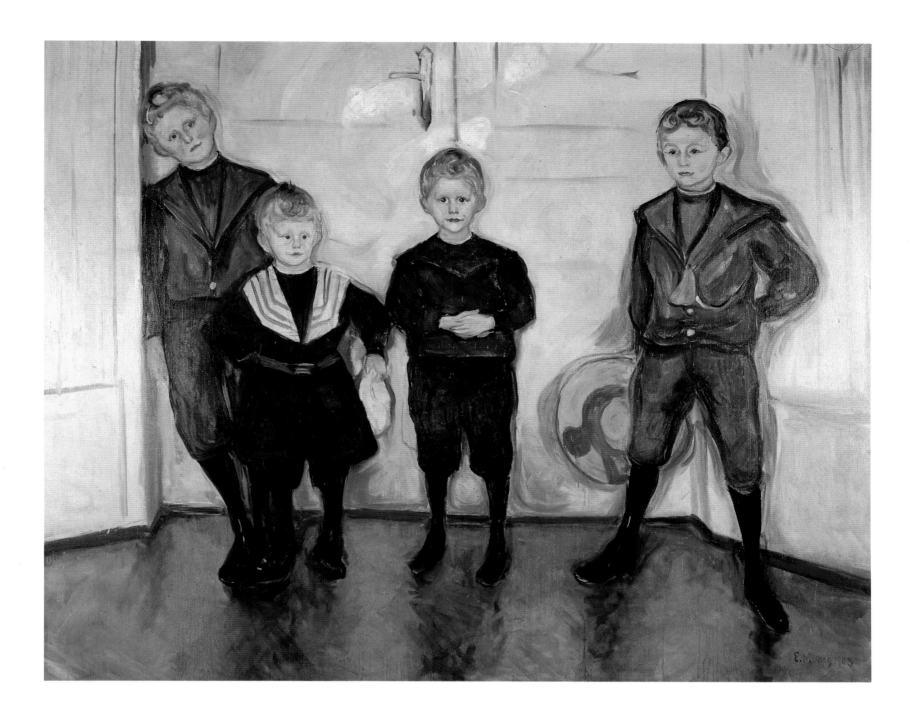

Dr Max Linde's Four Sons,

1903

Oil on canvas
56¾×78½ inches (144×199.5 cm)
Museum für Kunst und
Kulturgeschichte, Lübeck

Among the currents entering Munch's art around the turn of the century was a new concern with children. He had painted them before but only sporadically. Now and for a number of years they become an important icongraphic interest.

Max Linde, Munch's patron and friend, commissioned this picture as a birthday present for his wife. According to what Dr Linde said many years later, Munch painted the boys just as they appeared when he first met them. They had been called in from playing in the park and, shy but curious, they lined up in front of the door to the garden room to greet the distinguished foreigner. By the time he actually painted the picture, however, he already knew them well.

Of several famous precedents for such group portraits of children, the work this picture most immediately calls to mind is Hogarth's *Graham Children* (1742; Tate Gallery, London), which also depicts four children and to which Munch's composition bears a perhaps more than accidental resemblance in other respects. He constructs a careful design in two and three dimensions, although there is some ambiguity in the position of the eldest son. Only the third son, a mask-like expression on his face, looks as though he were actually posing for his portrait. He is placed almost exactly in the center of the picture, a stable frontal image forming a fulcrum, so to speak, for his more freely posed brothers, the two on the left adjoining him and thus perfectly balancing the more distant boy with the hat on the right. All three of these others are distinctively characterized: the oldest against the door jamb looks nonchalently bored, the youngest slightly apprehensive, while the boy on the right, his spread legs following the angle of the wall and an 'aura' emanating from his contour, seems by far the most alert; his face lights up with a Hogarthian liveliness of expression. By one who knew them when grown up it was said that as adults they all perfectly matched Munch's childhood characterizations.

Loving Couples in the Park (The Linde Frieze), 1904

Oil on canvas
35¾×67⅛ inches (91×170.5 cm)
Munch Museum, Oslo

In 1904 Munch executed another commission for Linde, a 'frieze,' actually eleven separate pictures, to decorate the large nursery at his house in Lübeck. When it was finished the doctor refused to accept the work, instead buying another picture for the same price. The decoration turned out to be too large to fit the room, and in addition Munch included love motives, as here, which Linde thought unsuitable for children and which he had explicitly asked him to omit.

Possibly this example again refers to the sequence of generations. We see only the top of the little girl's head; she belongs largely to the future, beyond the picture plane. The loving couple on the bench behind may represent her parents, and the two similar couples further back her grandparents. Farthest of all, the pair walking off into the distance could symbolize the endless precession of past generations.

Apparently with the aim of reproducing the primitiveness of a child's conception Munch has painted this picture as a rashly simplified pattern, so much so that it is difficult to unravel the winding paths, identify objects and determine space relations. Individual features are fused but contours lack the curvilinear flow of typical art nouveau. Instead they have become harsh and angular, as though distorted by the pressure of the multitude of stiff, wiry brushstrokes that impinge against them. The result is a quality of tension and discord that may well reflect the fact that this was a time when Munch was drinking heavily and involved in brawls. Even had the frieze suited his requirements in other respects Linde would have done well to reject this picture which, whatever its merits as an exhibition piece, would be disturbing to live with even for adults.

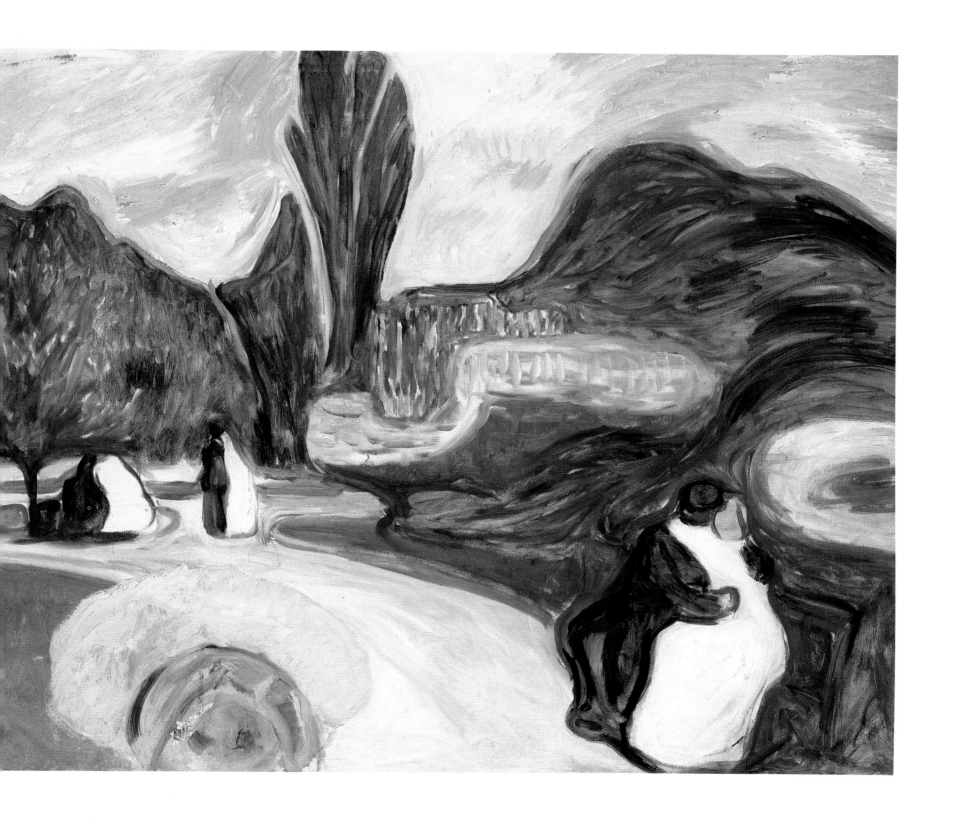

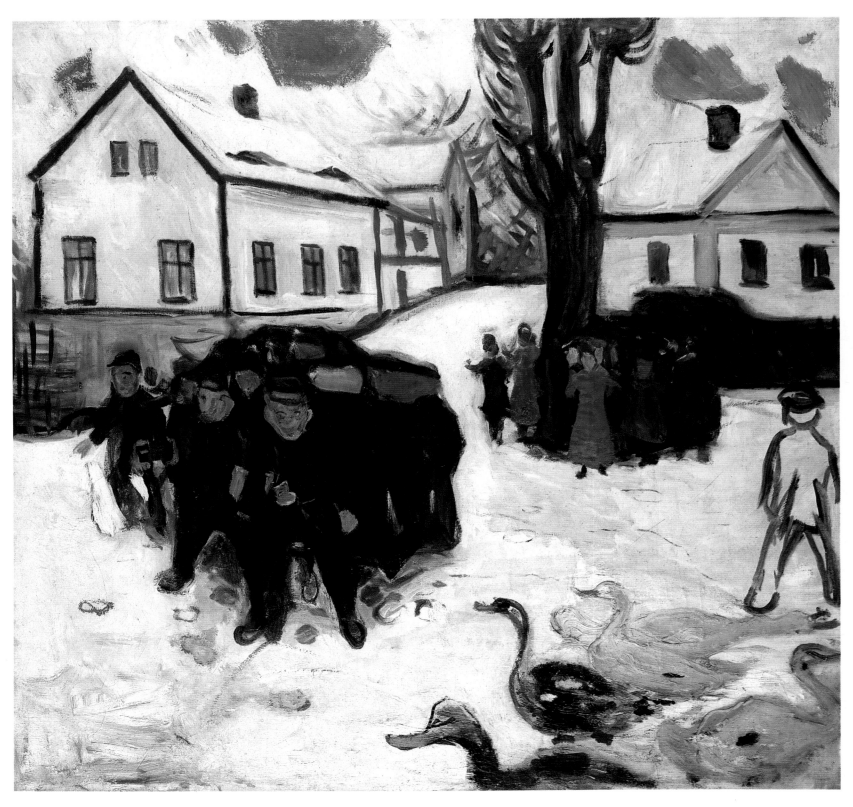

Young People and Ducks,

1905-08
Oil on canvas
39⅜×41⅓ inches (100×105 cm)
Munch Museum, Oslo

This picture was painted at Bad Elgersburg, a small spa in Thuringia, one of several Munch visited in efforts to relieve his nerves and alcoholism. However, he worked on it in later years, adding the solitary figure sketched on the right.

Here he revives a theme treated many years before in *Evening on Karl Johan Street* (page 36) and *The Storm* (page 39): the crowd versus the individual. But now he deals with it in a different spirit, not as a matter of internal anguish dramatized by stormy nights and haunted houses but as an objective, even humorous, pheno-

menon. It is simply a bright winter day in a village square, with brilliant primary colors against the white of snow and clouds.

Three separate groups are shown: the girls clustered around the tree in the background, the knot of boys, and the ducks in the extreme foreground. The boldest girl in red makes to leave her sisters and join the boys. The boldest boy, red-lipped and aggressive in mien, evidently has a different appetite; he heads for the ducks. Thus the groups are connected by intrepid individuals. But apart from them

the groups show signs of splitting up: two of the girls are leaving to walk up the road; the green-faced boy on the left, perhaps a scholar, begins to walk away clumsily, apparently about to trip over a plank; two of the ducks turn their backs on their comrades and move in the opposite direction, the one sedately, the other in fear or anger. The figure on the right goes about his business in isolation.

One might speculate as to whether it was Munch's intention to turn a microcosm of village life into an allegory of social disintegration.

Walther Rathenau, 1907

Oil on canvas
86⅝×43¼ inches (220×110 cm)
Rasmus Meyer Collection, Bergen

The first decade of the twentieth century was Munch's most important period as a painter of portraits other than of himself. While his practice varied considerably, the most characteristic examples followed his own iconographic precedent of many years before, *Karl Jensen-Hjell* (page 23); that is to say, they were full-length, life-sized portraits of male artists, writers and upper-class intellectuals. Inasmuch as they were usually people he knew personally as friends and patrons, to portray them did not violate the fundamentally autobiographical nature of his art and he could apply to them the same imaginative insight he brought to bear on other aspects of his experience.

Walther Rathenau (1867–1922) had been one of the first wealthy Germans to recognize Munch's greatness and had bought a painting by him as early as 1893. He was president of the big AEG company founded by his father and became an important social theorist and politician. When foreign minister he was assassinated by fanatical anti-Semites.

Allowing for a very different style 22 years later, this portrait has a good deal in common with *Jensen-Hjell,* both men carrying cigars in attitudes of haughty disdain. The effect is again achieved with the aid of a wide vertical angle of vision, in this case employed to elongate the left leg with its glossy shoe pointing downward. The downward thrust is reinforced by the thin diagonal shadow connecting the two feet to the base of the door behind; a parallel diagonal would be produced by a line joining door-knob, hand and bottom of coat. In contrast to this exaggerated descent the small head perched on top of the erect figure seems far away and aloof. Whereas Jensen-Hjell's hauteur smacks of posturing, Rathenau's seems the natural outcome of a superior intellect in affluent circumstances.

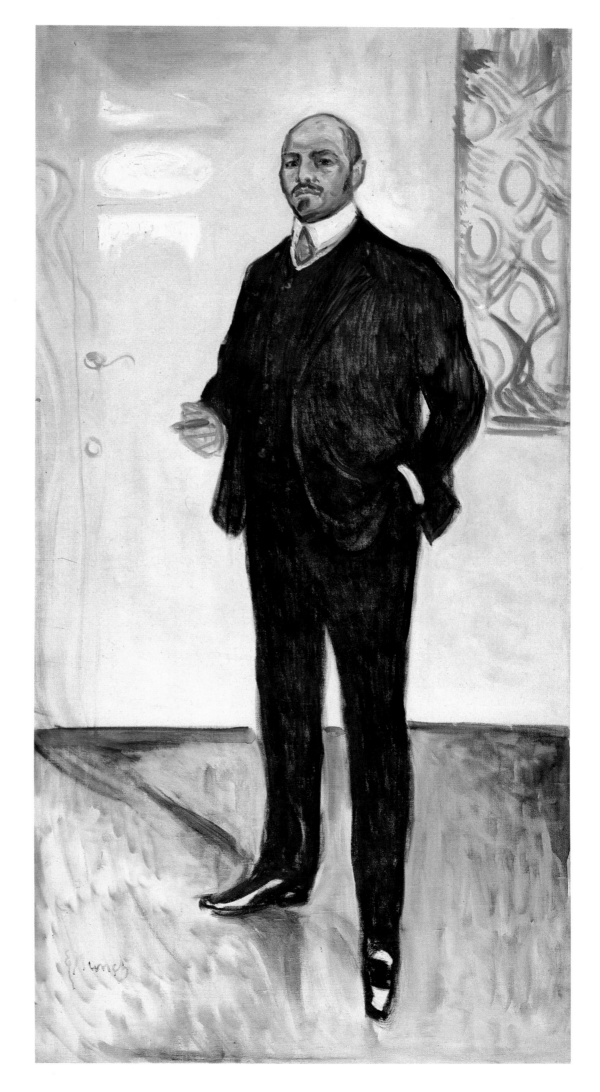

The Death of Marat, 1907

Oil on canvas
59⅞×58⅝ inches (152×149 cm)
Munch Museum, Oslo

Despite his new confidence in masculinity, the injury he had suffered in the Tulla Larsen dénouement and the alleged persecution at the hands of her 'cabal' of his former friends prolonged Munch's consciousness of female perfidy, leading him to contrive two different compositions entitled *The Death of Marat* (or *The Murderess*). The story of Marat's murder by Charlotte Corday bears only the remotest resemblance to that of Munch and Tulla Larsen but evidently it was enough for Munch's symbol-stretching mind. The idea may have been suggested by David's famous painting which, like the present picture, is based on a severely classical design of horizontals and verticals parallel to the picture plane. A nude Munch lying on a bed, blood dripping from his wounded hand, is substituted for Marat dying in his bath, and a nude Tulla, an erect frontal figure with her accomplished deed behind her, for the upright packing-case in David's picture.

The entire surface of the painting is covered with long, heavy stripes of paint in variegated colors with white interstices, arranged vertically and horizontally, in places cross-hatched, just as the composition as a whole is dominated by crossed vertical and horizontal figures.

Munch had previously used rather similar elongated stripes in woodcuts, and shorter parallel strokes of paint in some earlier pictures (e.g. page 35). Here they create an extremely agitated, atmospheric effect, conceivably a reflection of the artist's disturbed mental state; he painted in this manner especially in 1907, shortly before his breakdown, and now and then, in a less extreme form, for the next few years, during and after his stay in the Copenhagen clinic.

Munch later made some interesting comments on this style. He recognized, rightly, that it represented a break-up of art nouveau continuous contours and the synthetist reduction to a plane; he 'had the urge to break areas and lines,' as he put it, an urge already apparent in the tensions of *Loving Couples in the Park* (page 78). He also thought of it as a kind of proto-cubism, but here I believe he was mistaken. Destroying subjective fusion in his case, as in that of his Danish contemporary Willumsen, made possible a return to greater objectivity and realism. Cubism, on the other hand, was a step in the opposite direction, from subjective organic continuity, based on nature, to equally subjective inorganic articulation, largely discarding nature.

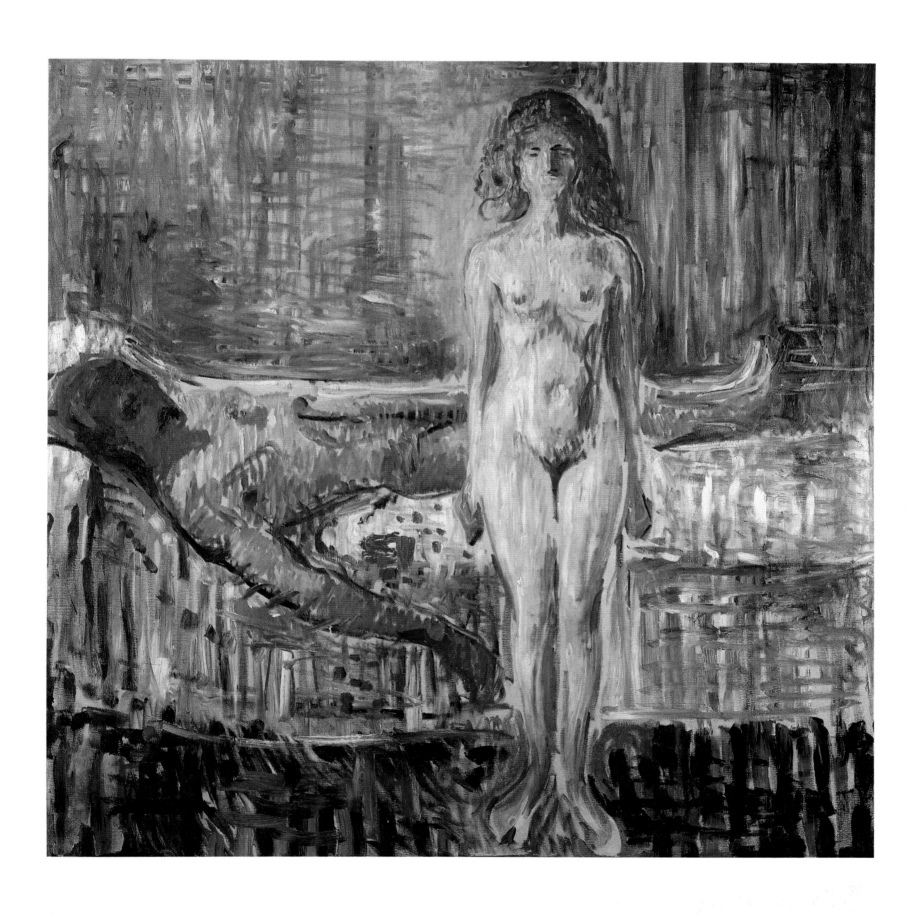

Worker and Child, 1908

Oil on canvas
30×35½ inches (76×90 cm)
Munch Museum, Oslo

At Warnemunde in the summers of 1907 and 1908 Munch painted several pictures of workers. In this example he takes up what became one of his favorite subjects, working men returning home from their work (cf page 94). A chalk drawing of the subject shows the factory they have left in the distance on the right. Here he applies to proletarian life an idea he had often illustrated in other contexts, the detachment of the individual from the group. What is unusual, however, is the reason for this detachment: the mutual love of parent and child, a theme he had until now rarely dealt with. Munch had been much preoccupied with love, which formed a whole department of his Frieze of Life scheme, but previously it had been almost exclusively erotic love, with its attendant pain and adversity, that concerned him. Perhaps it was his new enthusiasm for the child and the manual worker that prompted him to combine them in a scene of spontaneous joy in each other. Yet this happiness is not unqualified. Around his right arm the father appears to be wearing a black band of mourning, indicating that he has recently become a widower and the child motherless, thereby relating the scene to Munch's own experience. Although the man has left his companions and is divided from them by the diagonal curb of the pavement, he and the little girl remain approximately aligned to the intersecting diagonal formed by the walking men, which points to his belonging to the group even though temporarily separated. The painting is executed in a rough, emphatic style, with much use of heavy impasto in the whites, perhaps intended to match the simple lives and open emotions of the working-class people represented.

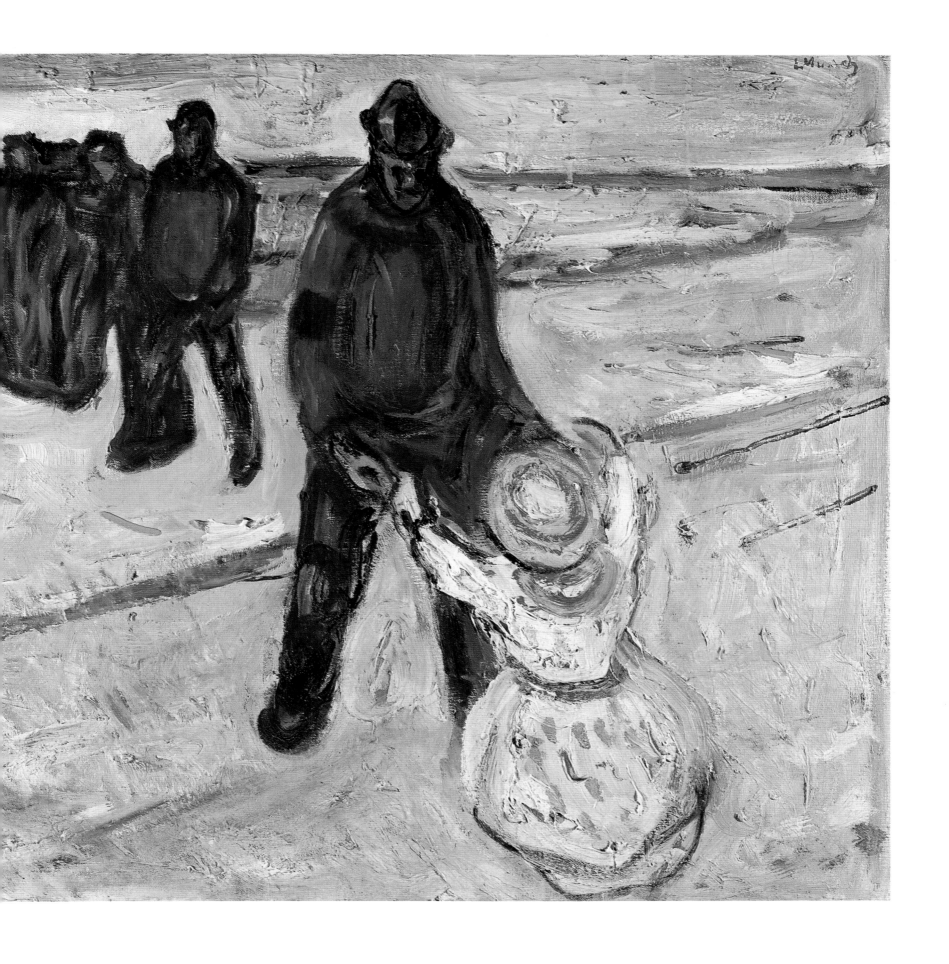

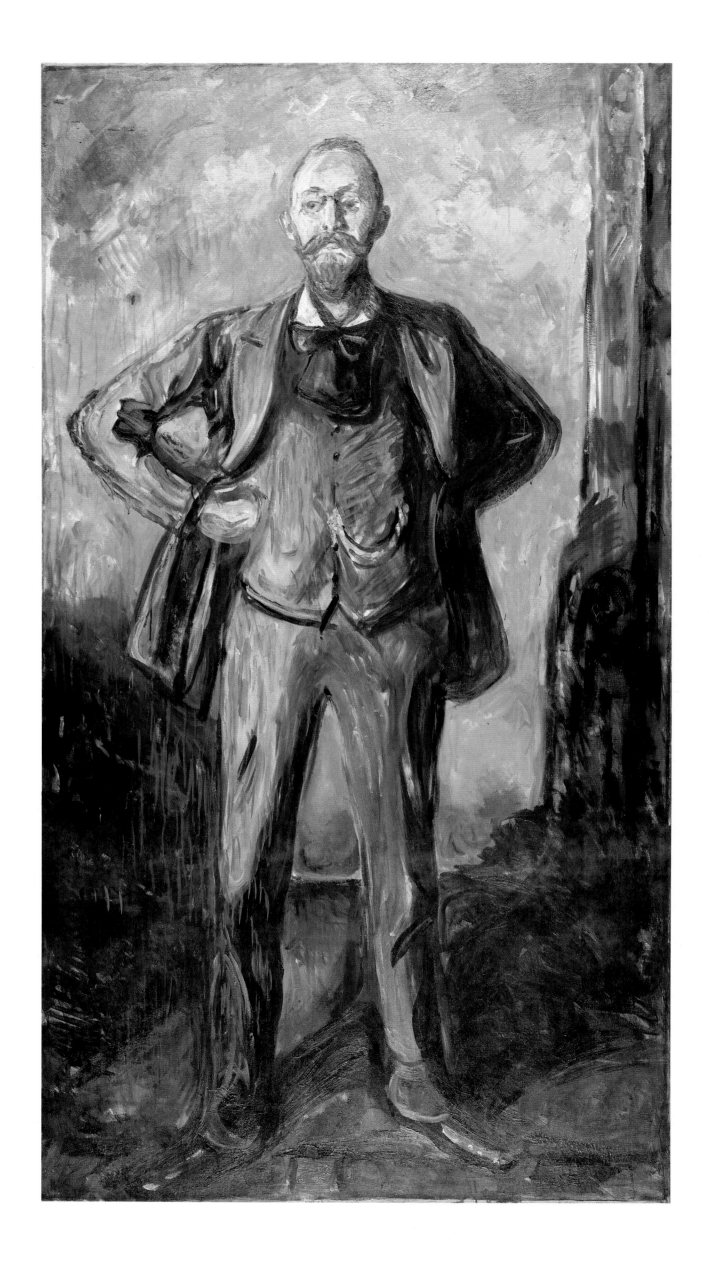

Dr Daniel Jacobson, 1909

Oil on canvas
80⅓×43⅞ inches (204×111.5 cm)
Munch Museum, Oslo

Professor Jacobson, was the head of the clinic in Copenhagen where Munch spent eight months recovering from his nervous breakdown. While there he painted this picture. Among all his full-length portraits it is unique in its freedom of color and handling. Obviously Jacobson was an imposing personality. A contemporary described him as a strange mixture of scientist, artist and poseur, all qualities Munch might be held to have captured in this extraordinary portrait. He clearly stood in awe of the doctor, and from remarks made many years later it would appear that painting this portrait was his way of for once asserting his own ego and supremacy: '*I wanted to say something too, so I asked him to pose for me. I placed him in the picture, big and strutting in a fire of color like all hell. Then he pleaded with me – became tame like a pigeon.*'

Planted firmly with his legs apart, Jacobson stands with one arm akimbo and the other behind his back, a mixture of swagger and withdrawal. The handsome head with its greenish moustache and beard is carefully modeled while the rest of the figure is largely rendered in parallel strokes of paint, mostly vertical, emphasizing the man's height. To the left, such streaks in bright red form a vibrating atmospheric accompaniment to the figure which in conjunction with the chaotic turbulence of the shadow on the right and the hot colors of the whole picture creates an effect of diabolical intensity. Art nouveau curves and synthetist image-patterns have virtually disappeared, to be replaced by an expressionistic, perhaps even caricatural, transfiguration of what is directly perceived.

Following pages:

The Sun, c. 1912-16

Oil on canvas
16 feet 11⅛ inches×25 feet 7 inches
(455×780 cm)
Aula (Assembly Hall), Oslo University, Oslo

The mural decorations of the University Aula were intended to symbolize natural forces affecting mankind as a whole, in contrast to the pictures of the 1890s he had hoped to assemble as a 'Frieze of Life,' which dealt with what he called 'the sorrow and the joy of the individual human being at close hand.' In fact there was a good deal of sorrow and not much joy in the proposed earlier assemblage, whereas in the university series Munch couples greater objectivity and generalization with optimism; there is no dwelling on his personal consciousness of misery and death. Eight of the eleven murals, the smaller upright pictures in the corners, are symbolic figure subjects. Two of the big horizontal canvases have figures set in panoramic landscapes: one, *History*, an old man telling stories of the past to a boy, the other, *Alma Mater*, a matron suckling a baby with other children nearby. Only the present picture, set in the end wall, is purely a landscape, and whereas all the others incorporate substantially new ideas reflecting a more complaisant view of mankind, here Munch refers back to an old idea, the sun with its sexual reflection traversing the sea. But the motive is energized and generalized; no longer a weak, romantic, moon-like sun fit only for arousing pale virgins on the shore but a blazing fireball powerful enough to fecundate the earth. The phallic column of light crossing the water now contains a small reproductive sun, suggestive of sperm, passing down towards the green area of land into which it will penetrate. On either side the land rises barren and rocky, like female thighs enclosing the fertile region. The blinding rays of sunlight are rendered by concentric yellow circles crossed by radiating line. As these lines get further distant they become interspersed with sections in various bright colors, perhaps suggesting that the light of the sun is the source of all color in nature. The landscape is recognizably Kragerø, with its rocky, wooded islands.

Except for this picture, the Aula decorations lack the intensity of feeling that could only come from a projection of the artist's personal emotions. Munch was too conscious of tragedy and decay to be entirely at home in taking, for public purposes, a one-sided optimistic view of life as a whole. How could he show *Alma Mater* convincingly when so conscious of his own premature loss of a mother? In *The Sun*, however, he was able to make public symbolism correspond to private, and thereby paint a masterpiece.

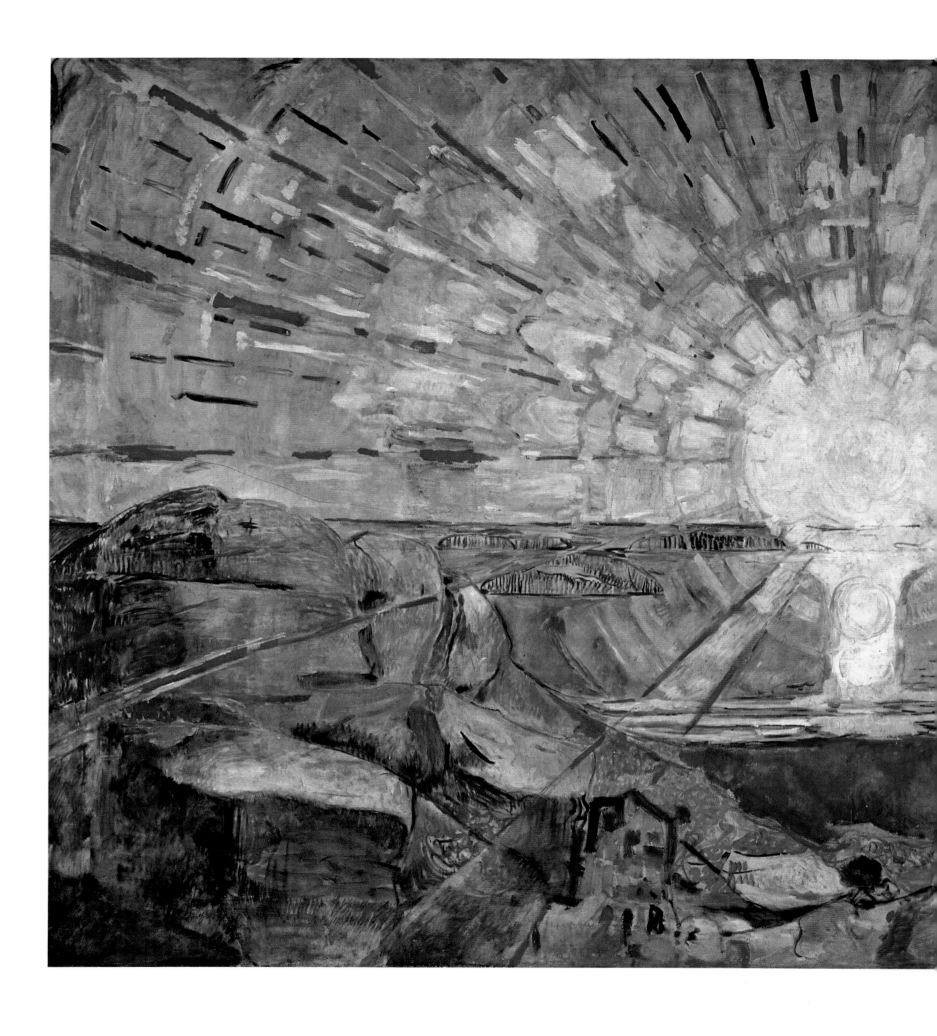

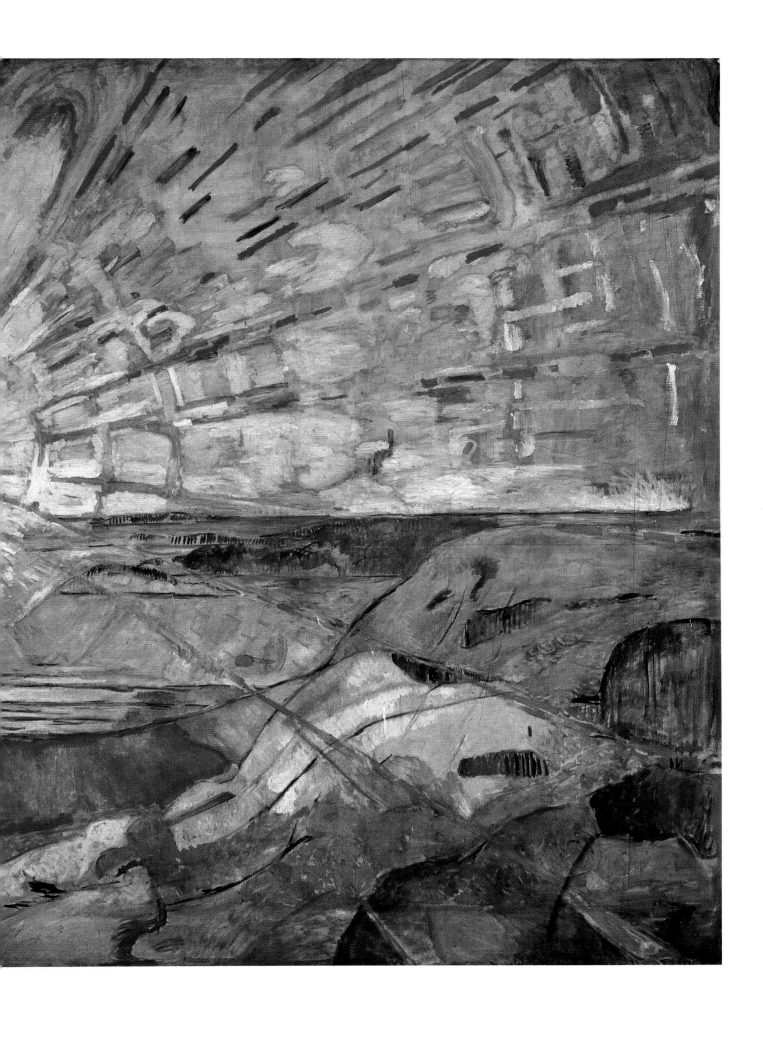

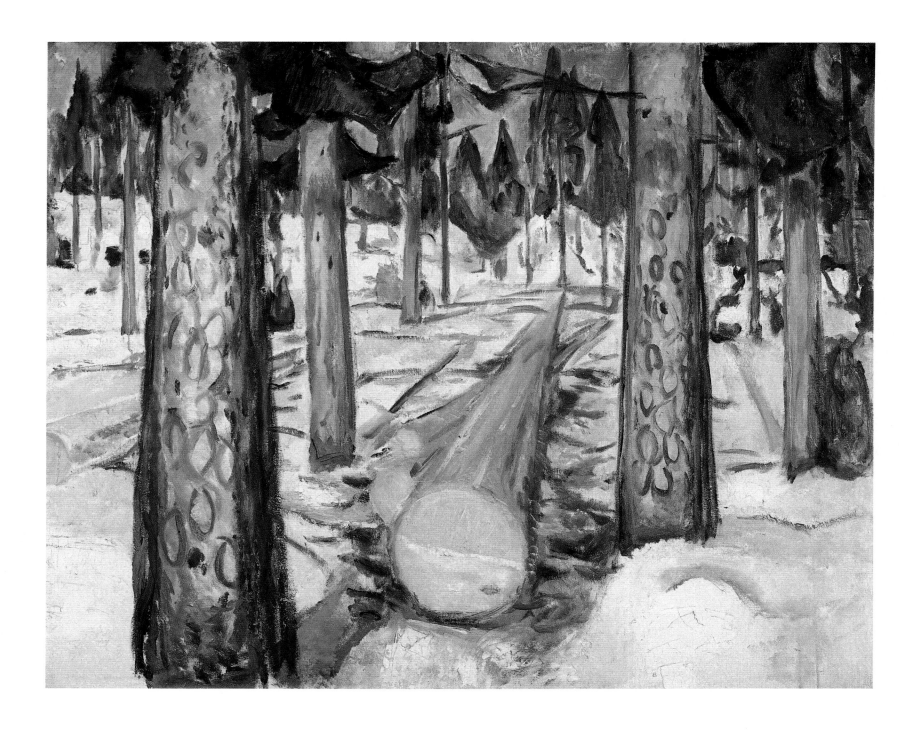

The Yellow Log, 1911-12

Oil on canvas
51⁹⁄₁₆×63 inches (131×160 cm)
Munch Museum, Oslo

At Kragerø Munch painted landscapes in the forests of spruces and pines in the neighborhood and on the nearby islands. Compared to his art nouveau-influenced woodland scenes of the turn of the century (cf page 70) this painting is relatively naturalistic, though colors have been intensified for expressionistic effect, especially the vivid yellow of the logs and the purple trees, doubtless to contrast life and death. The main yellow 'log' is in fact virtually an entire tree trunk stripped of its bark, bits of which in varied colors lie around it. Seen in perspective, its length seems exaggerated by the low eye level and short line of sight, and the great height of the tree when it lived, its 'Gothic' striving toward heaven, is emphasized by its pointing to the base of the tallest tree in the distance. The trun-cating of the tree in the extreme foreground by the top and bottom edges of the picture plane, indicating space continuing towards us, and the implied recession of the trees beyond both side borders, increase the already great sense of extension imparted by the fore-shortened 'yellow log.' The effect of all this is to make the forest seem endless in all directions.

The Cliff at Kragerø, 1910-14

Oil on canvas
36¼×44 inches (92×112 cm)
Munch Museum, Oslo

Unlike many of his modernist contemporaries, Munch rarely made any attempt to beautify the surface of his canvases with any kind of obvious dexterity, elegant handling of the brush or pleasing painterly texture. He usually painted thinly, and when he does employ impasto or other special effects with the brush or palette-knife they usually appear as attributes of what is painted, not as self-expressive embellishments of surface. Consequently surface texture tends to have little aesthetic appeal and is not allowed to distract from the pictorial content of the scene; the notion of the slick 'well-made painting' was foreign to Munch's conception of his art.

He had the idea that to appreciate his pictures properly it was preferable to see them from a distance. He was certainly right in this case. If looked at close up it appears comparatively flat but from a distance the forms spring into vivid three-dimensional reality. It is one of the most powerful of Munch's landscapes. Again the approach is basically naturalistic, but with obvious liberties of color, structure and handling – an imaginative response to a view actually perceived at a certain time under certain weather conditions. Hardly a trace of symbolism can be detected; the yellow patch in the distance is neither the sun nor the moon but a brightly lit building on an island in Kragerø Fjord, the opposite side of which looms darkly behind, and the reflection in the water is no longer a symbolic pillar but a more realistically conceived series of flickering dabs of color.

Yawning Woman, 1913

Oil on canvas
43⅓×39⅜ inches (110×100 cm)
Rolf Stenersen Collection, Bergen

All Munch's late replicas of early designs are in fact more of less free variations, but this picture, clearly based on *Puberty* (page 27), takes liberties that smack of self-parody. The pose and general design recall the earlier work but instead of being somber and serious the colors here are brilliant, even garish. A flabby and apparently mature woman, yawning from sleepiness or boredom (from a surfeit of love-making?), replaces the alert youngster conscious of the first stirrings of sex. She could be the same girl gone to seed; the time span between c. 1885-86 when the first version of *Puberty* was painted and 1913, the date of this picture, could be judged roughly equivalent to the age difference. The shadow behind her no longer suggests ominous associations, but is merely weak.

In a picture full of ambiguity and contradiction anybody's guess has to serve for interpretation. It is not clear whether the woman is getting up or going to bed. She seems to be dressing, and warming her cold feet like someone getting up. But she might be taking off the garment around her shoulders instead of putting it on, or it could be a night garment, and the bed appears unslept in. The shadow is placed as though the light came from the left, as in *Puberty*, and the lighting of the table bears this out. But on the woman herself the light comes from the right, and, again following *Puberty*, she bends her nearer leg away from it. That puts the shadow on the wrong side, and might even hint at another person in the room were it not that this shadow almost perfectly repeats the outline of her head and shoulder. On the wall to the left another shadow seems to be roughly sketched, its shape vaguely phallic. Bearing in mind Munch's conception of the prostitute, the woman's blowzy appearance suggests that that is what she might be; the dripped paint at the bottom could indicate unkempt surroundings. He had at times visited brothels, and depicted their inmates in several pictures, usually as fat, unattractive women. If she is indeed intended as a prostitute, she may be greeting or saying good-bye to the latest client, in either case with a yawn.

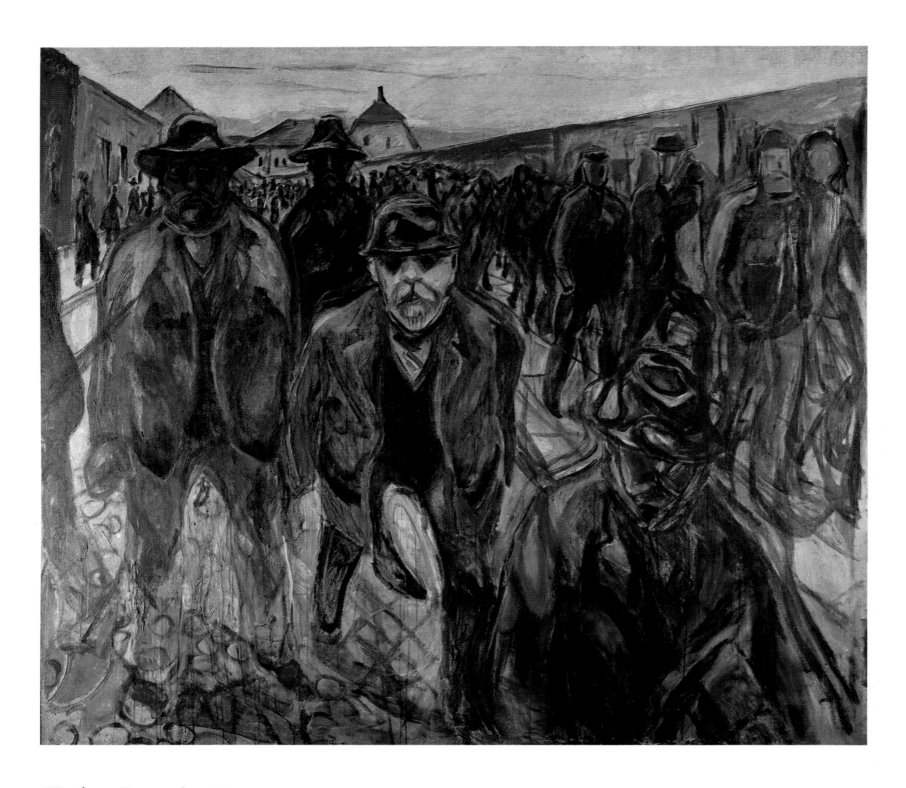

Workers Returning Home,

1913-15
Oil on canvas
79⅛×89⅜ inches (201×227 cm)
Munch Museum, Oslo

No other painting conveys so strongly Munch's belief in the working class as the dominant force in the society of the future. The tramp of the weary workers along the road home, from the distant vanishing point up to and beyond the picture plane, almost certainly signifies the march of the working class from the distant past up to the present and beyond it into the future, which is to belong to them. In contrast to this forward movement, and causing it to seem all-the-more relentless, the perspective shoots inward, accompanied in the middle ground on the left by a few small figures of bourgeois appearance; they recede into the past which, from Munch's standpoint, is where they belong. To augment the grandeur of the workers' procession he shows most of the scene from a low eye level, but as the foreground figures successively approach the picture plane the eye level rises in steps, so that the man in front, seen from a height and bisected by the base line, seems to be walking past us out of the picture, creating a cinematic effect. The use of multiple contours, especially evident in the leading figure, further increases the impression of movement. In fact the whole picture seems dominated by a tangle of wiry lines, more like a drawing than a painting; the lower legs of the man on the left are actually transparent, allowing us to look through them at the cobblestones.

All the men are dressed predominantly in blue, and all have grim anonymous faces dulled by long hours of heavy labor – except the truncated leader, who wears a wine-red jacket and whose face and hat bear a more than passing resemblance to those of Hans Jaeger, the initial inspirer of the sentiments expressed in the picture, who had died a few years before it was painted. Munch also identified himself with these workers. 'Do you know who's walking there?' he once remarked of this work, 'It's me, I tell you.'

94

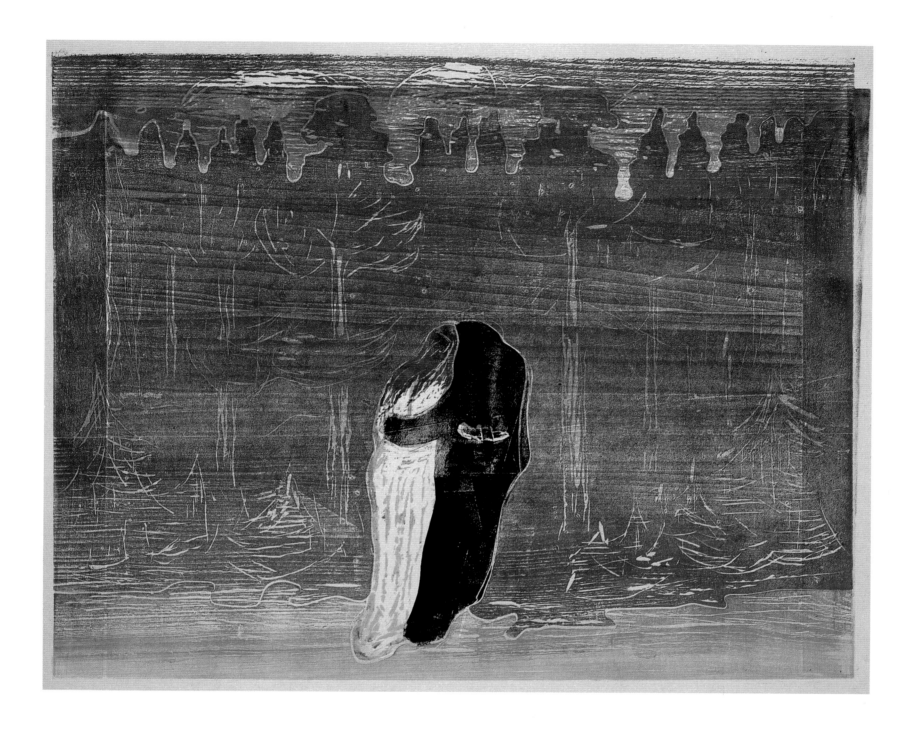

Towards the Forest, 1915
Woodcut, Sch. 444
20×25½ inches (51×64.6 cm)
Munch Museum, Oslo

The most characteristic technical device employed by Munch for color woodcuts, cutting the block into pieces printed separately, often leaving white lines between, was conducive to producing works rather like marquetry designs. This print demonstrates great skill in pattern design, with colors juxtaposed to contrast in light value as well as in hue. Though positive lines appear between the flat areas they are mainly white and hence lighter than either of the colors they separate, contrary to the usual practice in

painting of using black or darker lines. This gives the whole scene an ethereal quality, heightened by the delicate linear rendering of the tree trunks superimposed on the green of the forest, and the invisibility of feet, which makes the figures seem to float. Against the sky the tree tops present ghostly silhouettes; the two largest derive from the trees symbolically framing the two receding figures.

'Towards the Forest' can only mean towards death, 'the forest which sucks its nourishment from the dead.' In an earlier

version of 1897 the figure in black was a man and the woman in white nude. The changes made for this print, the woman draped and the black figure hooded and apparently also female, may have been suggested by Ibsen's play *When We Dead Awaken* (1900), in which the sculptor Rubeck, who has sacrificed the girl he loves for the sake of unworthy art, sees her at night among the trees, dressed in white and accompanied by a black-clad nun. Munch greatly admired Ibsen and drew illustrations to some of his plays.

High Summer, 1915
Oil on canvas
37⅜×47 inches (95×119.5 cm)
Munch Museum, Oslo

At Hvitsten on the eastern shore of Oslo Fjord, where he had bought a house a few years before, Munch painted a number of scenes of girls bathing or sunbathing on the rocks. He used his favorite model of the time, Ingeborg Kaurin. In this and other examples he obtained extraordinary effects of summer sunshine. Such pictures appear to confirm the idea that he took a more optimistic, objective attitude in later years, though this view is a trifle simplistic. Certainly this picture is strikingly different from *Inger on the Beach* (page 29)

of around 25 years before. Both show figures partaking of the surrounding rocks, but these are now brilliantly pink instead of grim and grayish, angular instead of smooth and worn. A comforting sociability replaces the former loneliness. Instead of only a tilted view of water the background now shows the opposite side of the fjord in realistic perspective, and instead of sitting like Inger in contemplative profile the girl in the foreground reclines at an angle to the picture plane, her posture echoing the angularity of the rocks

surrounding her. The extroitive joy of living becomes 'cubistic,' in contrast to the flat art nouveau fusion of the introspective pictures of the 1890s. This is not the studied abstraction and re-arrangement of a true cubism but the splitting up of fused curvilinear forms, like the bending of flexible sticks until they snap into straight, rigid fragments. Areas of blank canvas between the painted forms emphasize the quality of fragmentation, despite which the human figure remains relatively intact.

Self-Portrait in Bergen, 1916
Oil on canvas
35¼×23⅝ inches (89.5×60 cm)
Munch Museum, Oslo

Considering the vast quantity of Munch's self-portraits, collectively their scope is relatively narrow. That is not to say there is not variety of pose, situation, composition and style. But emotional expression ranges chiefly from calm to various types and degrees of distress or agitation. The mood is usually serious. Seldom does he show himself confident, cheerful, smiling or even reasonably happy. As can be gathered from some of his works as well as from reported conversations with friends, Munch did have a sense of humor. Only occasionally, however, and mostly in quickly drawn sketches, could

he summon the objectivity necessary to apply it to himself. If one compares the self-portraits with those he painted of other people the difference becomes clear. In the latter, by exercising his keen power of observation of characteristic postures and expressions, and in the case of those he knew well, intuitive understanding of the sitter's personality, he is often able in a single portrait to sum up the *character* of the person represented, that is to say, his or her enduring traits. This he is unable to do for himself except to a limited degree in a few works, notably the *Self-Portrait with Cigarette* (page 59). When in the

Self-Portrait with Brushes of 1904 he attempted to picture himself in the formal way he applied so brilliantly to many of his male subjects – standing, full-length, life-sized – the pose was stilted, the background uninformative, and the face a blank. What he often does succeed in doing is to convey vividly some unhappy mood of the moment, as in the present example. Here he accentuates his obviously disturbed state of mind by contrast with the normal bustle of everyday life in the background, from which he is separated by the window sill and a considerable height and distance.

The Man in the Cabbage Field, 1916

Oil on canvas
53½×71¼ inches (136×181 cm)
National Gallery, Oslo

After taking up residence at Ekely Munch painted a number of scenes of agricultural laborers in the surrounding countryside, of which this is one of the first and finest. In a way it is a rural counterpart to *Workers Returning Home* (page 94), with this time a solitary man, befitting farm labor, aggrandized by the low eye level and moving forward in a deep perspective composition. Nevertheless the scene appears quite flat, partly because the man blocks the view of the distant recession and vanishing point. Consequently despite his forward movement he acquires the timeless quality of a static image, a symbol of endless annual cycles of agricultural activity. Placed centrally with the perspective lines converging in the middle of his body, he and his work seem like an emblem of human existence. Like *The Fisherman* (page 72) he is spiritually exalted by being silhouetted in the form of a Gothic arch, but whereas the fisherman is an abstracted image the farm worker is tied to the equally spiritualized earth, for his Gothic arch is but the apex of a larger arch formed by the bending of the perspective lines. The cabbages he carries and those in the field around can scarcely be recognized as anything but haphazard blobs of color; the human figure survives in a chaotic world flattened by its amorphousness.

The Murderer in the Avenue,
1919
Oil on canvas
43⅓×54⅓ inches (110×138 cm)
Munch Museum, Oslo

The avenue is an avenue of time as much as space. Having committed his crime in the recent past, where his victim for whom time has ceased lies across its path, the murderer rushes forward into the future beyond the picture plane, whose base line decapitates him, condemned to suffer the punishment of conscience if no other. He has already lost his full humanity, for his face has become transparent and ghostly, defined only by rough outline through which the roadway can be seen. Munch had previously painted another composition called *The Murderer* (1910), in which the man's features have been blotted out by strokes of green paint.

Several possible causes have been adduced for Munch's mental breakdown in 1908, including especially the finger-shooting incident involving Tulla Larsen, which the painter himself cited. But it has not been much emphasized that in 1905 Munch came close to becoming a murderer, an experience probably just as traumatic as the Tulla Larsen affair. After a drunken brawl at Åsgårdstrand with his follower Ludvig Karsten, Munch aimed his rifle and shot at him. In later years, according to his friend Rolf Stenersen, he 'shuddered at the thought' of what would have happened had he not missed. It is important to remember that, though he blamed Karsten for the quarrel, he not only admired him as an artist, even considering him in some respects his equal, but was fond of him as a person, spoke of him often in later years after Karsten's sordid death in 1926, and made excuses for his heavy drinking and wild life. Besides the two *Murderer* pictures Munch produced an etching and at least four other paintings relating directly or indirectly to the Karsten incident (e.g. page 21).

Red House and Spruce Trees,

c. 1927
Oil on canvas
39⅜×51⅛ inches (100×130 cm)
Munch Museum, Oslo

In the 1920s Munch often sketched in watercolor (e.g. page 20), a practice that influenced this entrancing painting. Although it is quite a large oil painting the paint is applied in such thin, flowing, transparent washes that the effect is more like that of a watercolor sketch. White positive lines, doubtless influenced by his woodcut technique, contribute a ghostly quality. The scene comprises familiar elements – a lonely house with window 'eyes' behind 'Gothic' trees, the warmth of human occupation opposed to cold nature at dusk. Colors are more subtle than might appear at first glance, the blues are of many different shades and here and there are delicate pinks, purples and greens. The windows are set in two pairs at different levels, corresponding to the two pairs of trees in front and two patches of lighter colors in the foreground. Two irregular patches also appear in the sky. Even the house itself is bisected, or else consists of two semi-detached houses. All visible windows appear in the right half, whereas the left is largely obscured by a tree. No more than a hint of a window is revealed here, and what can be seen of the wall is not red but purple. On the extreme left stands a solitary tree, alienated from the rest, and perhaps analogous to the division of the house. Once again Munch may be referring to his old theme of the antithesis between the group and the individual, and possibly also between life and death.

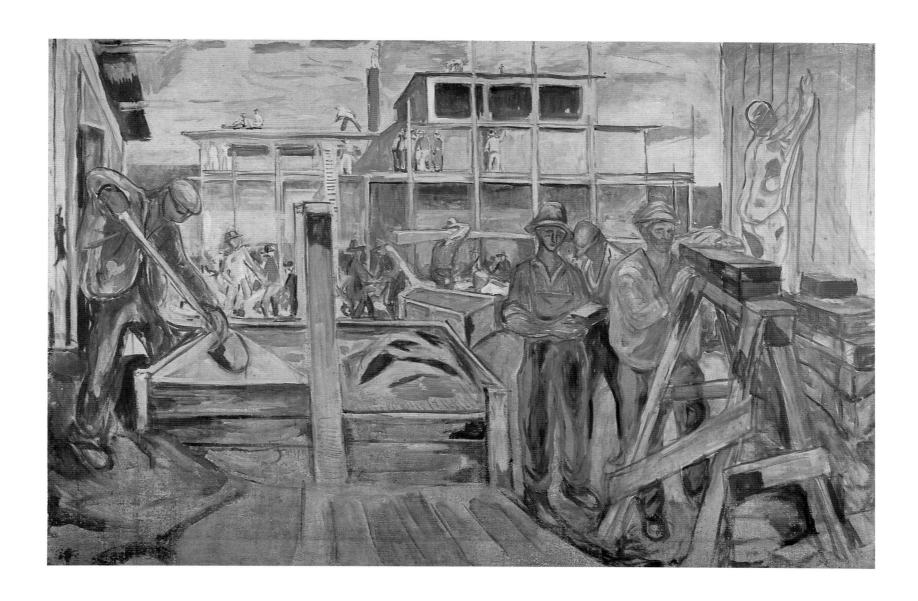

Building the Winter Studio,

1929
Oil on canvas
60¼×90½ inches (153×230 cm)
Munch Museum, Oslo

When in 1929 Munch had an imposing new studio built in the grounds at Ekely he made studies of the masons at work. Around this time he was also working on designs for his proposed, never to be realized, decorations for the new Town Hall; these too included, among other scenes of laborers, depictions of construction workers. For him building seems to have represented a form of practical activity with which he, as an artist, could especially sympathize; he may have thought of it as the application under pro-

letarian auspices of a new constructive order to a world which, to judge from many of his later paintings, he viewed as lapsing into chaos. He may also have been attracted to building by identifying himself with the protagonist in Ibsen's play *The Master Builder*.

This big picture was his most ambitious representation of building activity. Its monumentality clearly indicates that it was intended as a mural design. Its balanced, stage-like composition of masses arranged within a deep space sug-

gests that Munch was trying to emulate the great Italian Renaissance fresco painters. On his visit to Rome in 1899 he had admired Raphael's frescoes in the Vatican. The composition of *Building the Winter Studio* does in some respects resemble that of Raphael's *Fire in the Borgo* in the Stanza dell'Incendio, notably in the placement of the vertical supports of the sand bin, the figure against the wall with arm stretched upward, and the two architectural blocks, one behind the other, in the background.

Self-Portrait at the Window,
c. 1940
Oil on canvas
33×42⅓ inches (84×107.5 cm)
Munch Museum, Oslo

Between the Clock and the Bed, 1940-42
Oil on canvas
58⅞×47½ inches (149.5×120.5 cm)
Munch Museum, Oslo

In this late self-portrait the elderly artist grimly confronts the approach of death, symbolized by the dead tree in the snowy landscape seen through the window. Yet life is not extinguished. His head glows with a hot, ruddy incandescence, like a sun defying the sunless light outside, implying the survival of human life in opposition to the cold death invading all material objects, including his own clothing and even the radiator that is supposed to radiate heat. Far from offering any comfort, this radiator, painted to look like a set of double-edged serrations, only forecasts the lacerating process of dying. The light from the window coldly illuminates all the right side of the picture and the nearer side of Munch's jacket, throwing

the other side into shadow. But it fails to illuminate his face; on the contrary, it darkens the side nearest to it, while the farther side on the left is lit up by the light within, which is warm enough to redden the wall on the left behind his head. With his left eye Munch looks to the front, resolutely ignoring what fate has in store for him, but with his right he furtively attempts to squint at it around the obstacle of his nose.

On several previous occasions Munch had associated the idea of death or impending death with a window, for example in *The Sick Child* (page 24), *Spring* (page 7), *The Dead Mother* (page 40), and possibly also *Night in St Cloud* (page 33).

Uniquely among Munch's self-portraits this picture painted near the end of his life does not simply depict him in a particular mood at a particular time but presents a kind of autobiographical panorama of his life and death. As in other works, time flows forward from the distance to the picture plane. Through the open double door we see a room full of paintings, signifying his life work as an artist; another door in the far wall leads still further back, presumably into dim childhood. But now all this belongs to the past; he has stepped forward into another room where he stands impassively awaiting death, symbolized by a bed immediately in front of him. This bed is placed transversely, truncated by the border of the picture and flattened into a two-dimensional pattern, for though the act of dying occurs at a point in time the state of death is timeless. Its quilt has an ugly pattern of red and black stripes, perhaps suggestive of a

negation of life; Munch painted rather similar stripes across his chest in another very late self-portrait. Behind the door on the left stands a clock. Having neither hands nor numerals on its face it tells no specific time but merely symbolizes its passage, and since it is concealed from Munch by the door its function no longer concerns him. Similarly, hidden by the door on the right, behind the bed, hangs a picture of a female nude, probably meaning that 'knowledge' of the opposite sex now likewise lies beyond his ken.

The idea of associating a clock with the approach of death must derive from *Ten to Twelve*, a self-portrait of 1924 by his old teacher Krohg, also painted shortly before he died.

Girl with Pumpkin in the Garden at Ekely, 1942

Oil on canvas
50¾×39⅜ inches (129×100 cm)
Munch Museum, Oslo

Early in 1942 a young law student (at present anonymous) offered her services to Munch as a model, to help defray the cost of her studies. She worked for him for the better part of a year, until taking her exams, and visited him again late in 1943 only months before he died. For him she was more than simply a model, he valued her equally for her companionship and for providing new inspiration for his work. He seems to have paralleled himself to Solness in Ibsen's *Master Builder*, with the girl as Hilde, and they certainly discussed *When We Dead Awaken*, both plays involving the relationship of an artist to a much younger woman.

As well as any other, this picture proves that Munch could still paint masterpieces in his last years. It introduces a lyrical flavor new to his art. The scene is flattened to a tapestry-like pattern by the simplified forms, the high horizon, the variegated colors and the absence of shadow. Nature has become a chaotic collection of particulars, probably reflecting the way he now visualized the world, perhaps also the disorder in which he himself lived. But the anarchy resides in the discontinuity of these simplified particulars, not in the over-all design, which is beautifully balanced and contrived to link the girl in the foreground with the house high up in the distance, the two almost identical in their colours. The brilliant color scheme applied to abundant vegetation, with the extraordinary yellow sky, makes the garden at Ekely seem like a Garden of Eden, a paradise of primitive luxuriance lit up, as it were, by the white of the girl's dress and its echo in the window of the house. She carries this fruitfulness, in the shape of the enormous pumpkin, up to Munch's home, artistically a youthful Eve to his elderly Adam.

Short Bibliography

(Works in English, unless otherwise noted)

Benesch, Otto *Edvard Munch*, translated by Joan Spencer, London, 1960

Bischoff, Ulrich *Edvard Munch, 1863-1944*, Cologne, 1988

Boe, Roy A 'Edvard Munch's Murals for the University of Oslo,' *The Art Quarterly*, 1960, pp. 232-246

Deknatel, Frederick B *Edvard Munch*, New York, 1950

Digby, George Wingfield *Meaning and Symbol in Three Modern Artists: Edvard Munch, Henry Moore, Paul Nash*, London, 1955

Eggum, Arne *Edvard Munch – Paintings, Sketches and Studies*, translated by Ragnar Christophersen, London, 1984

—— *Edvard Munch og hans modeller* (exhibition catalogue, Munch Museum), Oslo, 1988 (in Norwegian)

Gauguin, Pola *Edvard Munch*, Oslo, 1933, 2nd ed., Copenhagen, 1946 (in Norwegian)

Heller, Reinhold *Munch – The Scream*, London, 1973

—— *Munch, his Life and Work*, London, 1984

Hodin, Josef Paul *Edvard Munch*, London, 1972

Langaard, Johan H and Ragnvald Væring, *Edvard Munchs selv-portretter*, Oslo, 1947 (mainly plates, brief introduction in Norwegian)

—— and Reidar Revold *Edvard Munch fra år til år: A Year by Year Record of Edvard Munch's Life*, Oslo, 1961

—— *Edvard Munch: Masterpieces from the Artist's Collection in the Munch Museum in Oslo*, New York, 1964

Lathe, Carla 'Edvard Munch and the Concept of "Psychic Naturalism",' *Gazette des Beaux Arts*, 1979, pp. 135-146

Loshak, David 'Space, Time and Edvard Munch,' *The Burlington Magazine*, April 1989, pp. 273-282

Messer, Thomas M *Edvard Munch*, London, 1987

Edvard Munch som vi kjente ham (contributions by K E Schreiner, Johannes Roede, Ingeborg Motzfeldt Løchen, Titus Vibe Müller, Birgit Prestøe, David Bergendahl, Christian Gierløff, Pola Gauguin, L O Ravensberg) Oslo, 1946 (in Norwegian)

Edvard Munch: Symbols and Images (exhibition catalogue, National Gallery of Art, Washington, DC; introduction by Robert Rosenblum; contributions by Arne Eggum, Reinhold Heller, Trygve Nergaard, Ragna Stang, Bente Torjusen, and Gerd Woll) Washington, DC, 1978

Przybyszewski, Stanislaw, ed., *Das Werk des Edvard Munch* (contributions by Stanislaw Przybyszewski, Franz Servaes, Willy Pastor, and Julius Meier-Graefe), Berlin, 1894 (in German)

Schiefler, Gustav *Verzeichnis des graphischen Werks Edvard Munchs bis 1906*, Berlin, 1907, Oslo, 1974 (in German)

—— *Edvard Munch: Das graphische Werk 1906-1926*, Berlin, 1928, Oslo, 1974 (in German)

Schneede, Uwe M *Edvard Munch: The Early Masterpieces*, tr. Anne Heritage and Paul Kremmel, Munich, 1988

Selz, Jean, *Edvard Munch*, tr. Eileen B. Hennessy, Naefels, Switzerland, 1976

Smith, John Boulton *Munch*, Oxford and New York, 1977

Stang, Ragna *Edvard Munch: The Man and the Artist*, tr. Geoffrey Culverwell and Anthony Martin, London, 1979

Stenersen, Rolf *Edvard Munch: Close-up of a Genius*, translated & edited by Reidar Dittmann, Oslo, 1969, 2nd English ed. 1972

Svænius, Gösta *Edvard Munch: Das Universum der Melancholie*, Lund, 1968 (in German)

Thiis, Jens *Edvard Munch og hans samtid*, Oslo, 1933 (in Norwegian; German condensation, *Edvard Munch*, Berlin, 1934)

Timm, Werner *The Graphic Art of Edvard Munch*, Greenwich, Connecticut, 1969

—— *Edvard Munch*, translated by Lisbeth Gombrich, Berlin, 1982

Varnedoe, Kirk 'Christian Krohg and Edvard Munch,' *Arts Magazine*, April 1979, pp. 88-95

Woll, Gerd *Munch and the Workers* (exhibition catalogue – Newcastle Polytechnic Gallery), Newcastle-upon-Tyne, 1984

Index

Acknowledgments

The publisher would like to thank Mike Rose who designed this book; Moira Dykes, the picture researcher; and Ron Watson who prepared the index. We would also like to thank the following institutions, agencies, and individuals for permission to reproduce the illustrations:

The Art Museum of the Ateneum, Helsinki: page 19 (below)
Drammens Kunstforening, Drammen (Buskerud): page 12 (below)
Lillehammer Bys Malerisamling, Lillehammer (Opland)/ photo O Vaering: page 28
The Munch Museum, Oslo: page 1, 2-3, 4, 6, 7(top three), 8(both), 9(both), 10(both), 11(top), 12(top), 13(top), 16(below)/ Private Collection 16(top), 17(top), 18(both), 19(top), 20(top)/ Gift of Rolf E Stenersen 20(below), 21(both), 25, 40-41, 45, 47, 62-63, 64, 65/Private Collection, 72, 74-75, 78-79, 80, 83, 84-85, 86, 90, 91, 94, 95, 96, 97, 100-101, 103, 104, 105, 106, 107, 109
Musée Francisque Mandet, Riom: page 7(bottom left)
Museum of Fine Arts, Boston: Ernest Wadsworth Longfellow Fund, page 42-43

Museum für Kunst und Kulturgeschichte der Hansestadt Lübeck: page 77
Collection, The Museum of Modern Art, New York: Gift of Mr and Mrs H Irgens and acquired through the Lillie P Bliss and Abby Aldrich Rockefeller Funds, page 39
**National Gallery, Oslo/Photographer Jacques Lathion, pages 7(bottom right), 11(below), 13(below), 14(below), 23, 24, 27, 31, 33, 35, 48, 50-51, 56-57, 59, 61, 66-67, 68, 70-71, 98-99
National Gallery, Prague: page 69
Ny Carlsberg Glyptothek: page 14(bottom right)
Private Collection/Photo Ornelund A/S: page 102
Rasmus Meyer Collection, Bergen: pages 22, 29, 34, 36-37, 49, 52-53, 54-55, 81
Rolf Stenerson Collection, Bergen: page 93
The Royal Library, Copenhagen: page 17(below)
Städelsches Kunstinstitut und Städtische Galerie, Frankfurt/ Photo Ursula Edelman: page 14(top)
Thielska Gallery, Stockholm: page 76
Trøndelag Kunstgalleri, Trondjems Kunstforening, Trondheim: pages 15, 38
University of Oslo, Oslo/Photo SCALA: page 88-89